This sponsors' page is an opportunity to acknowledge and thank each individual and company publicly for their vision and belief in this book. Each sponsor's decision to participate is based on a commitment to honor and celebrate the Grand Canyon and Colorado River.

PRIMARY SPONSOR

America West Airlines

SPONSORS

Mrs. Jack Harris	Residence Inn by Marriott, Flagstaff
Chums, Ltd.	C. Thomas Clagett, Jr.
Frances Guilden Gardner	

GRAND CANYON RIVER OUTFITTERS

Outdoors Unlimited	Arizona Raft Adventures, Inc.
Canyon Explorations, Inc.	Grand Canyon Dories
Arizona River Runners, Inc.	High Desert Adventures, Inc.
Grand Canyon Expeditions Company	Moki Mac River Expeditions, Inc.

HONOR ROLL

Grand Canyon Quality Inn & Suites	McCoy Motors
Verkamp's, Inc.	Women of Bank One
In Memory of R. P. Thurston	La Quinta Inn & Suites, Flagtaff
Northern Arizona University	

Sharon Skelly	Teva
Ocean Spray	Papillon Grand Canyon Helicopters
The Inn at 410 Bed & Breakfast	Cascade Designs
Embassy Suites Hotel, Flagstaff	Lou Grubb
Little America, Flagstaff	The Lodge at Sedona
Marble Canyon Lodge	Elaine & Larry Gourlie
The Ark Animal Clinic, Las Vegas	Grand Canyon Association
Arizona Office of Tourism	Fiesta Bowl

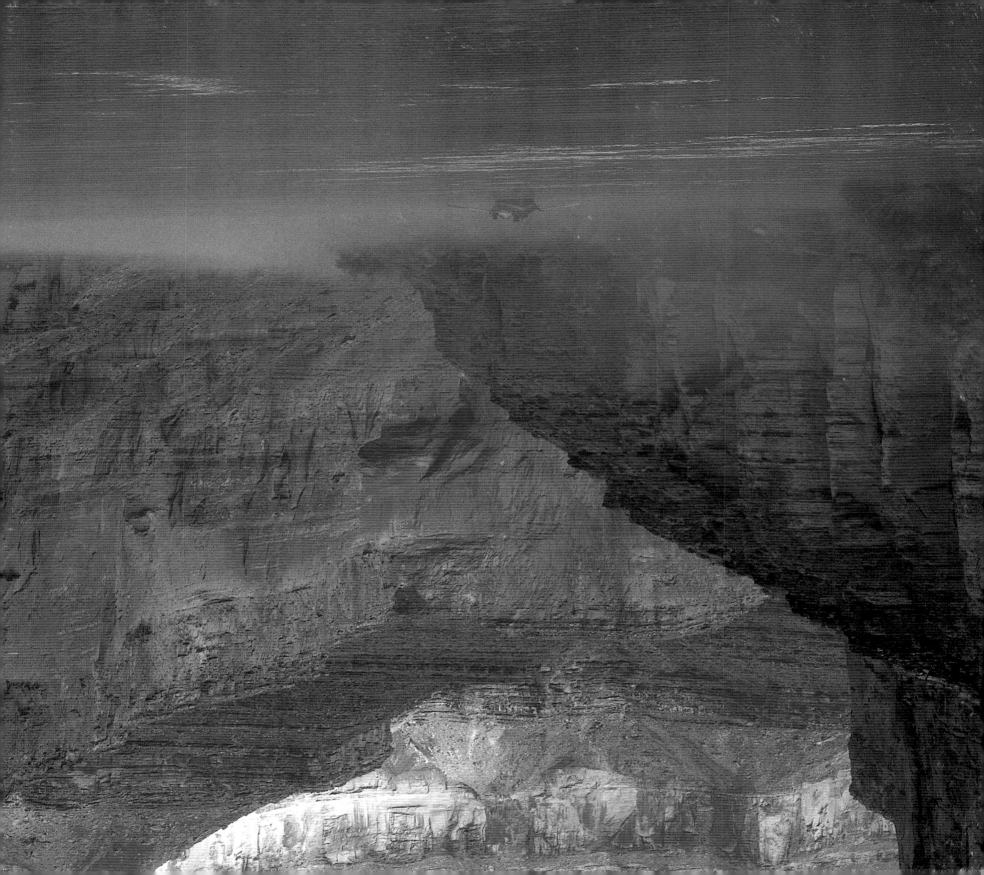

Writing Down the River

INTO THE HEART OF THE GRAND CANYON

photographed and produced by KATHLEEN JO RYAN *foreword by* GRETEL EHRLICH

essays by

DENISE CHÁVEZ • LINDA ELLERBEE • JUDITH FREEMAN • LINDA HOGAN • TERESA JORDAN • RUTH KIRK

PAGE LAMBERT • BRENDA PETERSON • LEILA PHILIP • SHARMAN APT RUSSELL • ANNICK SMITH

BARBARA EARL THOMAS • EVELYN C. WHITE • ANN HAYMOND ZWINGER • SUSAN ZWINGER

NORTHLAND PUBLISHING

The text and display type were set in Janson Text
Designed by Jennifer Schaber
Edited by Heath Lynn Silberfeld
Editorial Supervision by Erin Murphy
Production Supervised by Lisa Brownfield
Composed in the United States of America
Printed in Hong Kong by Midas Printing Limited

Frontispiece: *Fog downriver from Eminence Break*; Left: *Sacred datura*; Opposite: *Hike at Mile 193*

FIRST IMPRESSION, 1998
ISBN 0-87358-709-X
Library of Congress Catalog Card Number 98-11528

Ryan, Kathleen Jo, date.
 Writing down the river : into the heart of the Grand Canyon / photographed and produced by Kathleen Jo Ryan ; foreword by GretelEhrlich ; essays by Denise Chávez ...[et al.].
 p. cm.
 Includes index.
 ISBN 0-87358-709-X
 1. Grand Canyon (Ariz.)—Description and travel. 2. Colorado River (Colo.-Mexico)—Description and travel. 3. Grand Canyon (Ariz.)—Pictorial works. 4. Colorado River (Colo.-Mexico)—Pictorial works. 5. Rafting (Sports)—Colorado River (Colo.-Mexico) 6. American literature—Women authors. I. Title.
 F788.R93 1988
 917.91'320453—dc21 98-11528

0652/7.5M/5-98

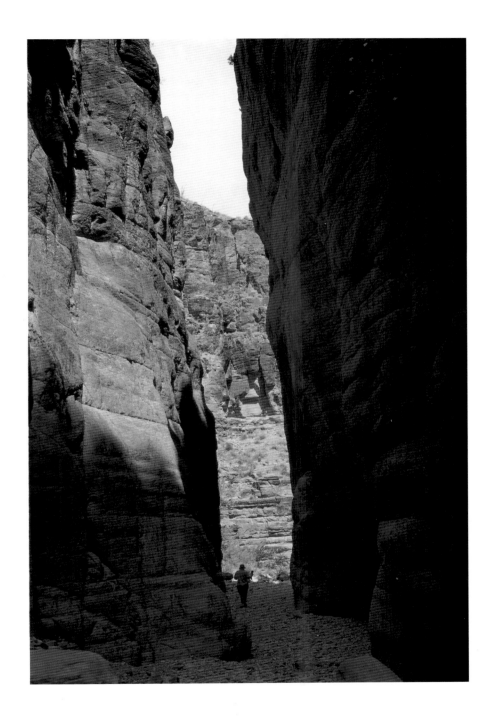

For their
unconditional love
and
gentle wisdom:

Mischel D. Whitehead
Joan Roulac-Torrence
Sharon Skelly
Fred Boeger

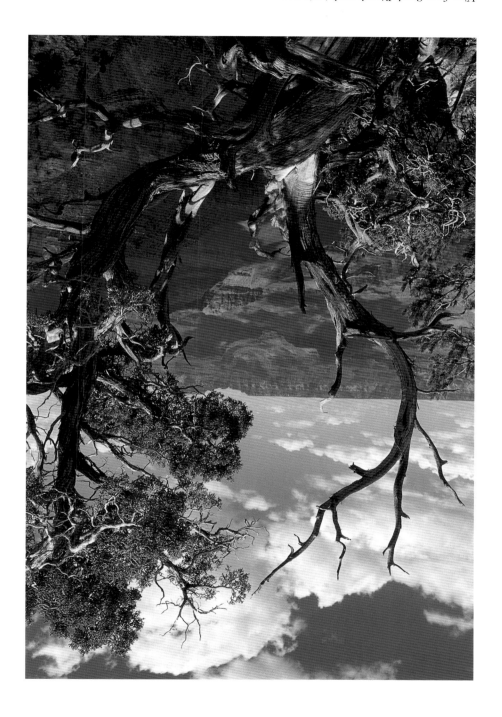

Contents

Foreword

GRETEL EHRLICH

ON MAY 24, 1869, THE ONE-ARMED John Wesley Powell, son of an itinerant Midwestern preacher, set out from Green River, Wyoming, with nine men in four wooden boats and rowed, drifted, spun, and careened down the Colorado River. Strapped in, with a single life vest and no hope of rescue, Powell ran rapids whose waves at flood stage were as high as three-story houses. The few scientific instruments brought along for research, a sextant and several barometers, were lost in the first capsized boat, though the barometers were recovered later. His journals, written on long brown strips of paper, sewn and bound in leather covers cut from a piece of hide, were saved.

Ninety-nine days later, the six haggard survivors, with barely enough food left for a week, emerged at the mouth of the Virgin River at a Mormon fishing camp. The geological, biological, physical, and spiritual revelations afforded these courageous explorers were as stunning and bewildering as those offered up to the finders of the Yellowstone Basin. Powell wrote

Hermit Rapid

about this first of two river journeys in *The Explorations of the Colorado River and Its Canyons* and accompanied his notes with marvelously detailed etchings. But he despaired of his effort, saying that in trying to capture the canyon's grandeur, "language and illustration must fail."

Such was the task facing fifteen women writers sent down the river on separate trips between April and October of 1997. Like Powell and his motley crew, some were inexperienced, some excited, and some frightened. Among them were two city dwellers who had rarely seen the stars. One writer put down her fork at dinner the night before going down the river and said, "This trip isn't dangerous, is it?" It wasn't danger they were seeking, but life lived full and in the present. And the river gives just that. *Writing Down the River: Into the Heart of the Grand Canyon* is a reporting back not only of edgy fears but of wonderment, exultation, and surprise. Teresa Jordan, a ranch-raised Wyomingite, now living in Nevada, wrote, "For twelve days and 280 miles on the river, I am filled with awe—so struck by it, in fact, that if I have any courage at all, I shall never be the same."

Two major rivers make up the Colorado—the Green River, which bubbles out of the verdant slopes of Fremont Peak in Wyoming, and the Grand River, whose source is six miles west of Colorado's Long's Peak. The carving of the river is the work of these two streams and their many tributaries, which in the spring of the year and in the summer are swollen by meltwater and monsoon rains.

Two hundred and seventeen miles long, from four to eighteen miles wide, and one mile deep, the rocks that form the great gorge were exposed by eight million years of erosion and repeated geological sequences of deposition, uplift, and submersion at the bottom of which a river insinuates itself—as if it were Time, cutting down, down, down. While the massive weight and velocity of these interfeeding rivers tore a channel through rock, the surrounding land was being uplifted. Looking at the canyon, I wonder how a place created by erosional forces could appear to have become so much more.

It's October and the last writer is off the river. Unprecedented rains lashed Arizona all summer, and two hurricanes passed through. In anticipation of El Niño, a more than

usual amount of water was released at Glen Canyon Dam in an effort to make room for the winter rains and snows to come. Often, the volume of water passing down the gorge was very high.

The August morning John Powell was about to enter the main part of the river, which he called the "Great Unknown," he wrote, "We are three quarters of a mile in the depths of the earth, and the river shrinks into insignificance as it dashes its angry waves against the walls and cliffs that rise to the world above; the waves are but puny ripples, and we but pigmies, running up and down the sands or lost among boulders."

Who wouldn't feel fearful when facing these kinds of natural powers? Barbara Earl Thomas, an urbane Seattleite, battling a painful memory of her parents' drowning, bravely ventures onto the river: "Life is cruel, but if I am tempting fate it's not death I fear as much as life's irony. I could not bear the thought of my family having a shoe drop in the same pond twice." She goes anyway, puts up her tent at day's end, but opts to sleep outside for the first time in her life, and marvels at the sky lurid with stars.

Like someone on a plane going down, Sharman Apt Russell spent the first few hours of the trip acknowledging her "herd-animal instincts," trying to evaluate who her companions were. "With our small talk and small gestures, we build what we need to become, a short-term tribe."

Denise Chávez also starts off with abject fear. "There is a sense of the ludicrous in this scenario: A woman with a fear of heights and rapidly moving water." But she ends with a powerful prayer of gratitude: "Blue sky. Bless me. Wall of rock. Bless me. Animal friends: Red Ant, Blue Heron, Bighorn Sheep, Chuckwalla. Bless me. Plant friends: Desert Willow, Brittlebush, Snakeweed. Bless me. This is your home. I am merely a visitor."

Recovering from a bout with cancer, Linda Ellerbee starts off her moving personal essay dryly: "I am not supposed to be here." She runs the rapids: "Whoooosh. Breath knocked right out of me. Whoooosh. Don't forget to breathe out. That's what John said. Breathe in at the bottom of the trough. That's what Julie said. Swallowing green and swallowed by green. The world tumbles up and over." Afterward, at home in New

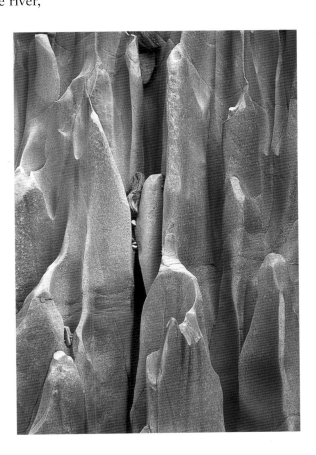

Fluted granite

York, troubled by a cancer survivor's fear of death, she wills herself back onto the water and finds sanctuary there.

To others, the river trip was a cornucopia of intimacies: Linda Hogan focuses on the plant, datura, used for centuries by her Native American ancestors in a sacred manner. Teresa Jordan scrutinizes a family of barrel cactus and a cube of Zoroaster granite. Judith Freeman watches two frogs mate under a full moon whose light slides down canyon walls. Brenda Peterson finds her still center, then rails against the unnatural act of damming a river. Ann Zwinger, an unparalleled naturalist and an old river hand, closes her eyes, cups her ears, and listens to the canyon's reverberations, what John Wesley Powell described as "the melody of the great tide rising and falling, swelling and vanishing forever." Meanwhile, Evelyn White hums a Tina Turner song.

Ruth Kirk, not fearful, but exultant as she contemplates being a mile down in the earth, states plainly, "I prefer Down-Here." Susan Zwinger writes of a hike into one of the side canyons where she stands in the embrace of a pounding waterfall: "I fling myself back inside with arms stretched wide open and head tilted back, right up into the central air hole. A thousand pulsating showerheads pound, thunder, hammer, thrum, and pulverize my head. My clothes are pummeled, my hair is pummeled. All the dirt, sweat, bug-juice, sun-grease, nose-snot, heat-rot, and smoke-scum are hosed off my joyful skin; my soul is polished clean."

Annick Smith, Leila Philip, and Page Lambert all tell of the stunning power of the big rapids. Lambert writes, "Like a young lioness unaware of her own strength, Lava toyed with us. We surfaced, coughing and sputtering, only to be thrust under the waves again and again. We clung to each other, not daring to let go. Finally, the River turned us loose."

Philip, homesick for her six-month-old son Rhys, says, "To be a mother, a guardian of new life, is to become implicitly conservative." Later, she is flipped out of her kayak by a ten-foot wave: "Before I know it, twin walls of water are rising up around me. The kayak is sucked forward and then up then down into a cauldron of boiling whitewater. I feel the boat buckle, then flip like a potato chip and I am tumbling."

Smith's stirring tale of her boat capsizing in Hermit Rapids is called "Falling into the Canyon." She writes, "I go down a long way. Buried in the brown deep, I'm a pebble in a maelstrom. This is power pure, power strong enough to drive turbines. I am holding

Chuck Wales, boatman, negotiates Granite Rapid

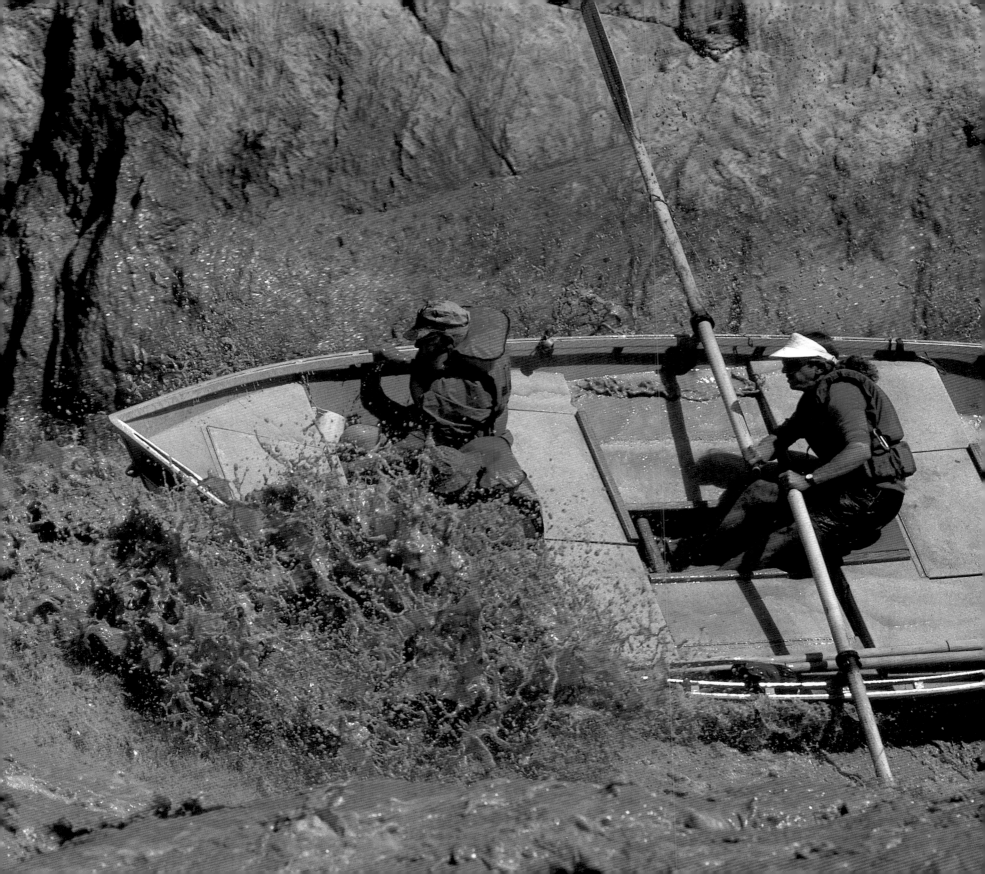

my paddle. I let it go. I push up through the icy turbulence until breath leaves me and I am choking, swallowing water." When she comes up and is rescued by a boatman, she's bleeding. A paddle hit her in the face, leaving a welt on her forehead and blackening an eye. But she's sanguine about the event. "It's made me stronger and more humble. . . . More surefooted, but less sure in my head. I've learned a few things about mortality." She finishes the day with a stiff gin and tonic.

Now it's October and I'm standing on the South Rim. Everyone is off the river. There's a chill in the air and the oakbrush that cloaks canyon ledges has turned orange. All day I've been watching the sun's fire touching the thousand-citadel whole-rock city of the Grand Canyon and have tried to follow the sinuous course of the river far below. Once I caught sight of Hance Rapid, but from so great a distance it looked only like a mild

bend with a lacelike riffle, not a broken piece of water so powerful you could die in its tousled waves.

A wind stirs. All I can think of is questions. Why did the earth split here? Why so deep? Did the river do the cutting or did the mountains lift up? Why have the necks of rock been skinned and why do they rise in towers? Who made these cliffs look like flames? Why is the canyon a tree of life, all branches, all fruit, all leaves, standing in green water?

At Shoshone Point there is absolute quiet. Canyon wrens and mountain bluebirds flit silently from juniper to pine to green clumps of Mormon tea. It is not a straight-down leap to death from here, but a jagged cakewalk of escarpments, flying buttresses, thin ledges holding single bonsai trees. Several times today, a russet-colored coyote has crossed my path, and two mule deer, a buck and a doe, lift their heads as I dangle my legs off an edge. My calls of greeting to passing ravens, learned from a Navajo sheep-herder twenty-five years ago, go unheeded.

Evening. It's time to leave. The writers who journeyed down the river this summer are safely home, but they all say the river still courses through them. I walk the rim and watch tenebrous shadows slide across this craggy giant of a gash in the earth.

A sudden rain splash darkens everything. Farther down, the canyon twists and splits a million times, and the spinal curve of green, blue, and brown water embraces half-moon arcs of sand, jade pools, and the crystalline strings of narrow waterfalls.

I look and look—there is so much to read in rock and desert and water—and I can't help wondering how many ways water shapes the body, how body shapes desire, how desire moves water, how water stirs color, how thought rises from land, how wind polishes thought, how a stream that carves through rock is shaped by rock.

From Navajo Bridge the river is celadon with red silt mushrooming up like boiled, unspooling brains. The shadows sink. They lie on green water. Then the whole canyon goes black.

GRETEL EHRLICH
October 1997

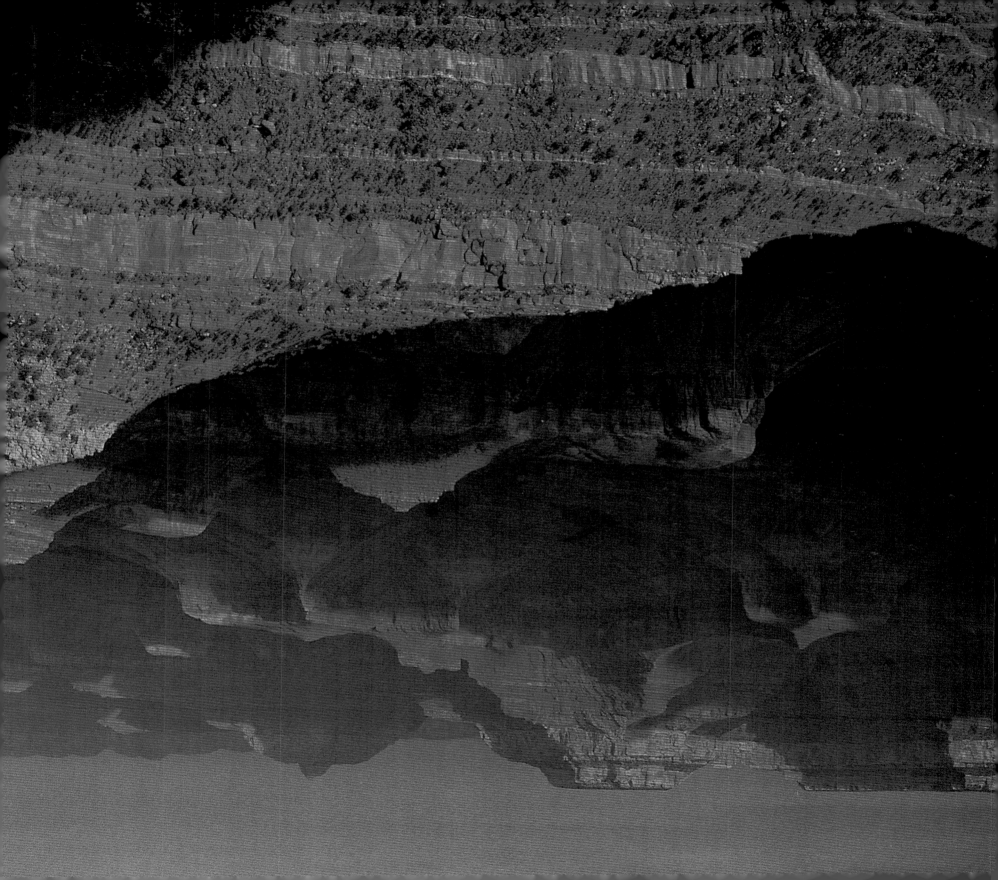

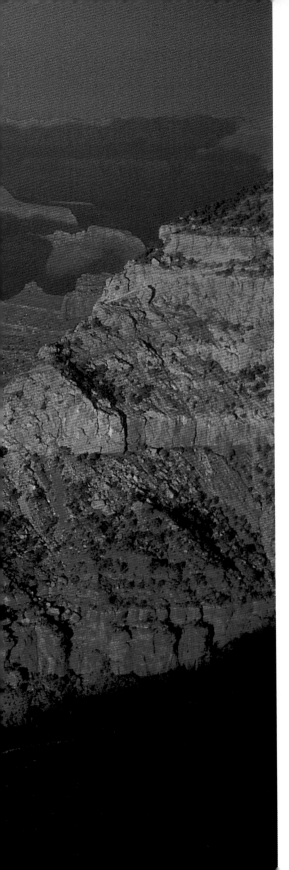

Introduction

K A T H L E E N J O R Y A N

O N AN OUTCROPPING OF ROCK I SIT snuggled in an oversized wool coat as a brisk fall wind drowns out the sounds of people and cars. I have returned once more to the South Rim of the Grand Canyon to feel the space and magnitude and to contemplate the perspective before I turn in the final elements of this book. I am overcome with a tingling sense of gratitude and blessing that I am about to complete this inspired project, a vivid dream for nine years.

From my perch I am overwhelmed with the contrast between what I see and what I feel. From the South Rim, the experience is orderly, almost antiseptic, and does not require risk or effort. There are paved turnouts and neatly organized guard rails to direct the 5 million visitors who come every year. The Canyon I have come to love appears forbidding, barren, hostile, almost lifeless, and beyond my reach. The magnitude numbs and I am lost in a sea of insignificance. I feel restless, unsatisfied, and bewildered. Eventually I focus on a view that reveals the Colorado River below and I am immediately transported into the Canyon's intimate heart.

View from South Rim

In her depths, the Canyon seduces us as we slowly float downriver. The first rapids are playful riffles and there is an imposing silence, the only sounds the boatman's oars slipping in and out of the water, punctuated by an occasional song from a canyon wren. In the distance a murmur begins, a quiet rushing sound that escalates and demands attention. Soon it is thundering. The boatman repositions and alerts the passengers to prepare for the descent into a rapid. We slide seductively down the tongue into a crescendo of energy and water; the water seems to be laughing as we enter for the ride, applauding as we complete each wave. We gasp from cold water hitting our hot skin and from the exhilaration of the rampaging power. As quickly as we brace ourselves, we shoot through to the other side of the rapid while the boatman deftly glides us past the eddies. We have been awakened, our senses aroused. There is extraordinary power in this passage, yet it would be easy to accept only the superficial experience. As with people, though, the real power lies beneath the surface.

Yet the Canyon does not impose—it awaits perception, recognition, interpretation. With each river journey my learning accelerated. I soaked up the environment: Space, magnitude, color, texture, wind, and water became more familiar while the power of the water demanded more and more attention and respect.

This past summer, the water was running high on each of my trips. On two of them, a raft in front of me flipped, tossing the passengers into the wild water; but no one was hurt and with great team effort each boat was returned to its upright position and we continued downriver. These events reached deep inside me and fueled my vulnerability, taking hold from my fatigue and lifelong fear of water.

My own personal passage of seven accumulated river trips has been arduous, strengthening, and bountiful. My five river journeys of the past year happened after I turned fifty; my most powerful birthday. I am a former athlete, not a current one, although I look capable. In my youth I had been an above-average swimmer. Yet I have never overcome my panic and terror of being in water out of control. Intellectually I recognize it as an irrational fear that my skill has never resolved. On each trip I really pushed myself. By my last trip I was feeling physically defenseless. Just the thought of flipping sent waves of terror through me. As my boat approached each major rapid, I found myself praying: "Holy Father, please may I have safe passage." If it was necessary

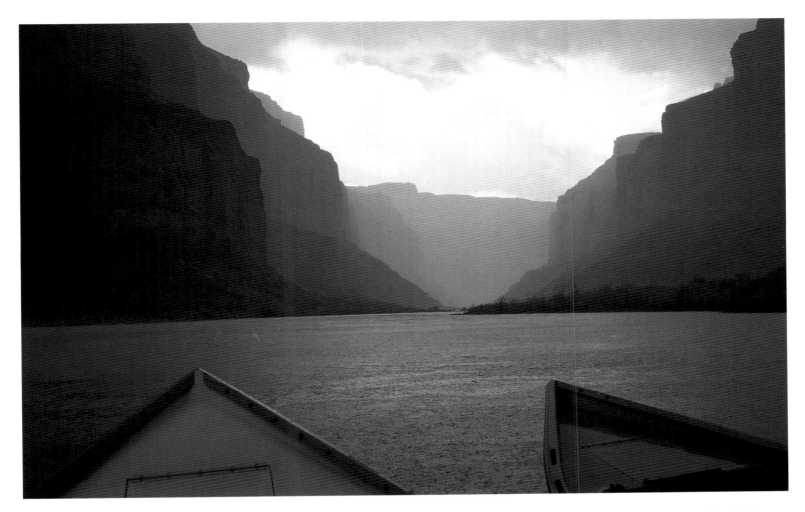

Looking downriver from Nankoweap

In her depths, the Canyon seduces us as we slowly float downriver.

for me to complete my River experience—although I was convinced it was not—I asked the River to be gentle that I might learn without harm.

On my last trip, we scouted Lava Falls, where another flash flood had created a dramatic debris flow from Prospect Canyon that changed the run our boatmen were accustomed to making. They scouted as I photographed the wild water. We had three boats go first, all successful. Then I was seated up front in the last boat, and I vividly remember dropping into the enormous and raging water, which was much higher than our eighteen-foot dory. As we began to drop down I thought, *This is really big.* Then the boat flipped us. I was tossed about like a rag doll, panicked, and unable to breathe. I saw no signs of land, no other boats—only mocha-colored water. I finally saw the dory—upside down—coming toward me. I grabbed the edge. The boatman, who had grabbed the other side, urged me to climb on.

I started to catch my breath, but I did not have enough strength to pull myself out of the water. As I struggled, my knee popped out of its socket, an ungainly event that happens at inappropriate times. The boatman pulled me up onto the overturned dory, and as I flopped onto it my knee popped back in place. I was unaware of how quickly we were being swept toward the wall at Lower Lava—where all the water crashing through Lava Falls and raging downstream slams against a rock wall on river left. Our boat was headed directly for the wall.

The boatman remained very calm and directed me to hold my flip line, which encircles the bottom of the boat, and to lean back and away from the approaching wall. We missed the first sharp edge by inches. We were within a couple of inches of the next edge when the force of water rebounding off the wall caught the edge of the dory and flipped it upright. We were thrown back into the water, and though the boat was swamped it remained right side up. Amid the raging current, another boatman maneuvered his dory next to ours and pulled us up into our boat. The entire event took only about three minutes. We stopped on the beach to regroup—my sunglasses still held in place by my Chums—and, miraculously, I had not swallowed any water.

When a boat flips it becomes a social event for the group. Adrenaline is high, the crisis is over, and waves of emotional relief circulate. It is time to celebrate a positive outcome. But that night I sought solace. I felt emotionally rearranged and humbled. I needed comfort. As I lay awake, secure in my cocoon sleeping bag, watching the canopy

of stars, I played the whole scene over in my mind. My worst fears had been realized: I had panicked, was totally out of control, and could not catch my breath. It might have been fun had I given myself to the moment and to the current. But I had been filled with terror. I wept quiet tears of reassurance, of ownership, of overcoming and acceptance. I had been baptized, completed a rite of passage. A shooting star winked at me.

The Grand Canyon has been—and continues to be—formed by cataclysmic events as well as millions of momentary changes. Still the whole is ever-present: changing yet undiminished. I ask myself: Why are we afraid of dramatic or devastating change in our own lives? In ourselves? Is it possible to recast what we perceive to be negative as some-thing beautiful, something sculpting our lives, our psyches, our souls? Aren't we, like the Canyon, made new again and again, yet always infinitely whole?

Going down the River into the heart of the Canyon is adventuring into a place of spirit. I hold a warm, overwhelming feeling of gratitude, respect, and humility for having been allowed to float and play through this majestic canyon. I will return with an even greater sense of openness and receptivity so I can continue to learn the infinite secrets held within.

In 1987, while crisscrossing twelve Western states and losing myself in the open spaces of the American West, I drove across Navajo Bridge and crossed Marble Canyon. I stopped and walked back to the middle of the bridge and looked down at the Colorado River. I wistfully asked the river to extend me an invitation. I went on my way. That moment was lost in thousands of miles as I drove throughout the West during the next year.

A year later, an invitation came from a boatman friend working on the Colorado River for the summer of 1988. In 1986, my friend had introduced me to river rafting with a single trip on the Toulumne River in northern California. By September 1988, I was finishing my book *Ranching Traditions* and felt a river trip would be fun, a change

Going down the River into the heart of the Canyon
is adventuring into a place of spirit.

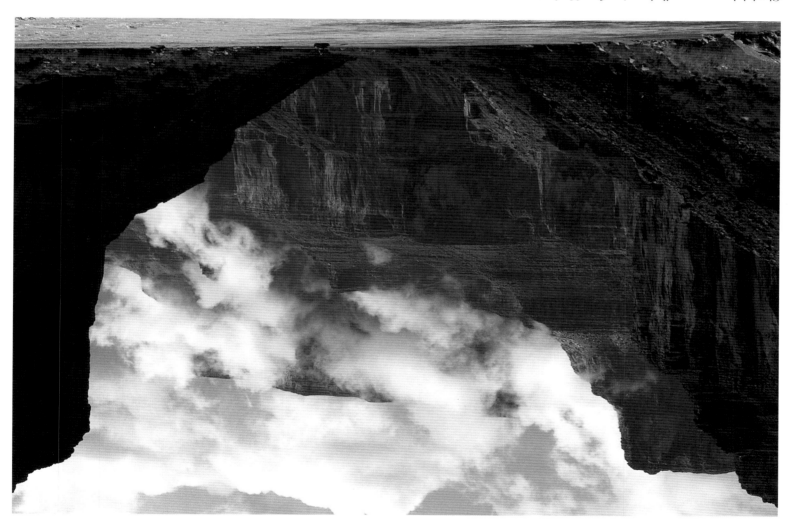

Clouds below canyon walls downriver from Nankoweap

of pace from traversing the American West by car and on horseback. I traveled to the Colorado River and went into the Grand Canyon without expectation, experience, or knowledge.

After returning from the River I searched for a book to validate and celebrate my feelings for the Grand Canyon and Colorado River experience. I did not find such a book, and *Writing Down the River* evolved naturally from that search. I signed a book contract with Northland Publishing and returned to the Canyon for a fifteen-day river trip in October 1996 to officially launch this project. At last, my vision began to take form. At once thrilling and daunting, the project was what I had sought for eight years.

In addition to doing all the original photography, I am the project producer and secured the funding for all project expenses prior to publication, selected the writers, and organized all logistics. I did this for the "risk-reward ratio": the higher the risk, the higher the opportunity for reward. For a project of this complexity, the risk is great, and my reward lies in ensuring the integrity and quality of the images and words and creating an enduring published book. I am responsible for selecting each of the women writers whose work fills these pages. My selection process was, as always, subjective. After researching each writer's work, I considered how her writing style moved me visually. Of the sixteen writers whose work is published here, I previously knew only a few. The rest I wrote to or phoned, shared my vision with, and invited to participate.

Eight Grand Canyon outfitters—out of sixteen permitted to run commercial river trips in the Canyon—sponsored all the writers' trips this past summer. The first writer put in on April 1 and the last writer came off on October 2. I photographed on four trips: one motor, two raft rowing, and one dory rowing.

It is interesting to note that during fifteen writers' trips and all four of mine this summer, virtually no injuries occurred. One writer's boat flipped in the ledge hole at Lava Falls Rapid, one writer was knocked out of her inflatable kayak by ten-foot waves, another writer's paddleboat flipped in Hermit Rapid. And of course, after a total of six trips without incident for me, on my seventh trip I flipped in Lava Falls Rapid. It was an extraordinary summer.

I asked each contributor to share her personal journey, whether an experience of healing, exuberance, revelation, awakening, or something else. The resulting essays reflect each woman's passage—each essay is as individual as each woman. Thus, this

of pace from traversing the American West by car and on horseback. I traveled to the Colorado River and went into the Grand Canyon without expectation, experience, or knowledge.

After returning from the River I searched for a book to validate and celebrate my feelings for the Grand Canyon and Colorado River experience. I did not find such a book, and *Writing Down the River* evolved naturally from that search. I signed a book contract with Northland Publishing and returned to the Canyon for a fifteen-day river trip in October 1996 to officially launch this project. At last, my vision began to take form. At once thrilling and daunting, the project was what I had sought for eight years.

In addition to doing all the original photography, I am the project producer and secured the funding for all project expenses prior to publication, selected the writers, and organized all logistics. I did this for the "risk-reward ratio": the higher the risk, the higher the opportunity for reward. For a project of this complexity, the risk is great, and my reward lies in ensuring the integrity and quality of the images and words and creating an enduring published book. I am responsible for selecting each of the women writers whose work fills these pages. My selection process was, as always, subjective. After researching each writer's work, I considered how her writing style moved me visually. Of the sixteen writers whose work is published here, I previously knew only a few. The rest I wrote to or phoned, shared my vision with, and invited to participate.

Eight Grand Canyon outfitters—out of sixteen permitted to run commercial river trips in the Canyon—sponsored all the writers' trips this past summer. The first writer put in on April 1 and the last writer came off on October 2. I photographed on four trips: one motor, two raft rowing, and one dory rowing.

It is interesting to note that during fifteen writers' trips and all four of mine this summer, virtually no injuries occurred. One writer's boat flipped in the ledge hole at Lava Falls Rapid, one writer was knocked out of her inflatable kayak by ten-foot waves, another writer's paddleboat flipped in Hermit Rapid. And of course, after a total of six trips without incident for me, on my seventh trip I flipped in Lava Falls Rapid. It was an extraordinary summer.

I asked each contributor to share her personal journey, whether an experience of healing, exuberance, revelation, awakening, or something else. The resulting essays reflect each woman's passage—each essay is as individual as each woman. Thus, this

book is about taking risks; trusting oneself and trusting others; following instincts and intuition; and summoning courage to face fears and buried feelings, longings, or desires. And seeking answers.

Once the women were on the river, I had instructed them to write about their personal journeys, with the River, the Canyon, and the river guides as their companions. I trusted this process implicitly. Each writer came to the River with her own expectations, challenges, cautions, excitement, and fears. Spanning four decades in age, from the mid-thirties to the early seventies, some had never slept out under the stars or been on whitewater. Two traveled with spouses, two with another writer, and the rest alone. We were accompanied on all our journeys by groups of strangers who were paying passengers on the trips.

This book is a gift to each of us who have been blessed to participate in it, and these words and images are our gift to you.

KATHLEEN JO RYAN
October 1997

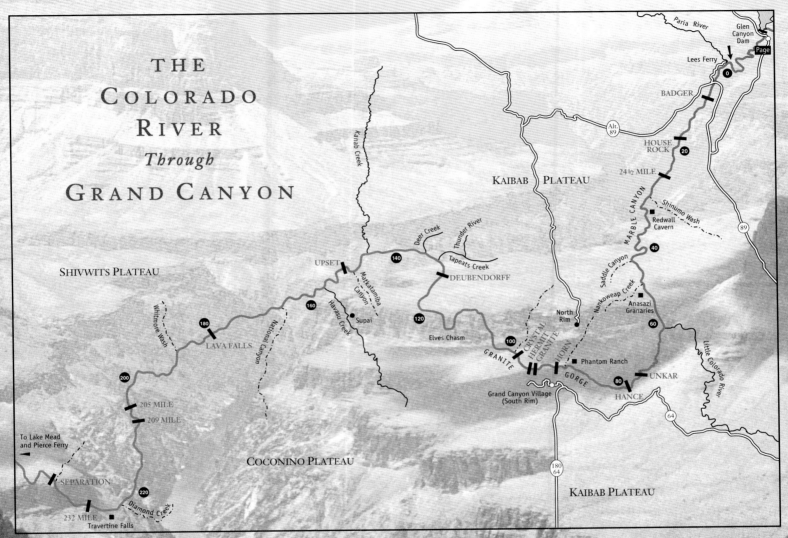

THE

COLORADO

RIVER

Through

GRAND CANYON

Paria River

Glen Canyon Dam

Page

Lees Ferry

0

BADGER

Alt. 89

HOUSE ROCK

20

24½ MILE

MARBLE CANYON

Shinumo Wash

Redwall Cavern

89

KAIBAB PLATEAU

Kanab Creek

Deer Creek

Thunder River

Tapeats Creek

UPSET

140

DEUBENDORFF

40

SHIVWITS PLATEAU

Matkatamiba Canyon

Supai

120

Elves Chasm

Saddle Canyon

Nankoweap Creek

Anasazi Granaries

60

Havasu Creek

160

North Rim

Whitmore Wash

180

National Canyon

100

CRYSTAL

HERMIT

GRANITE

GRANITE

HORN

Phantom Ranch

Little Colorado River

LAVA FALLS

GORGE

200

80

UNKAR

HANCE

Grand Canyon Village (South Rim)

205 MILE

209 MILE

64

To Lake Mead and Pierce Ferry

COCONINO PLATEAU

180
64

SEPARATION

220

KAIBAB PLATEAU

232 MILE

Diamond Creek

Travertine Falls

Based on a map in *Western Whitewater*, courtesy of North Fork Press

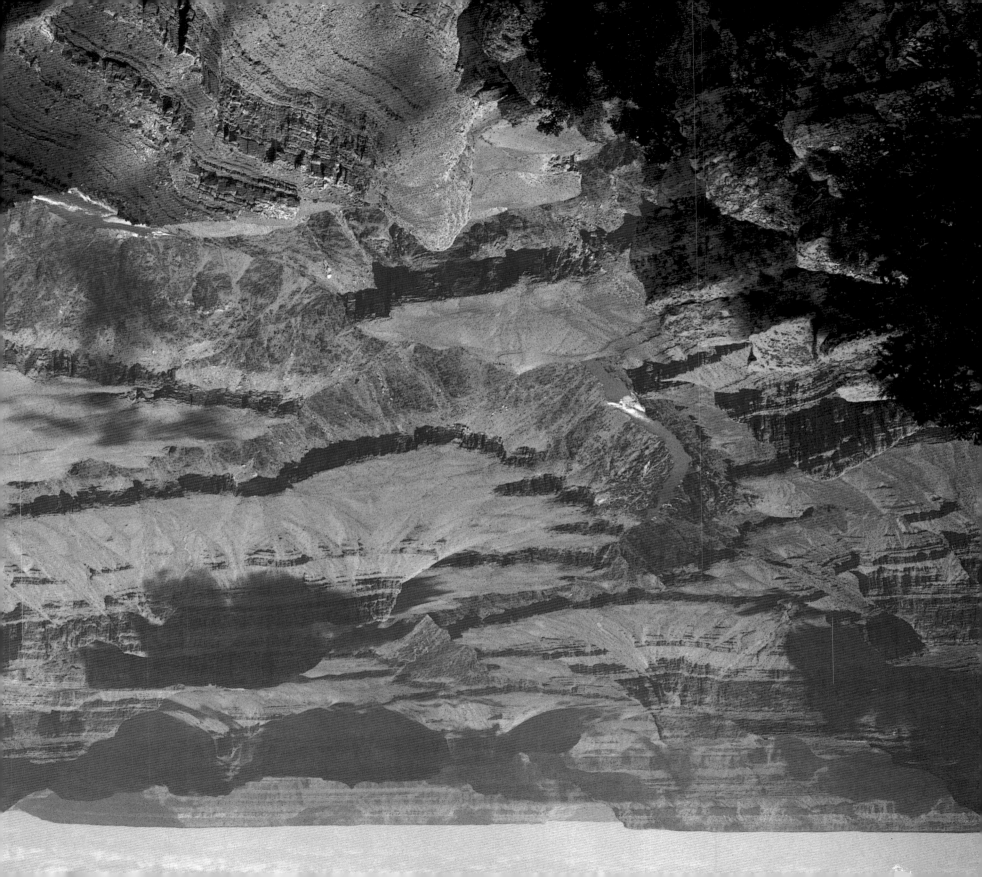

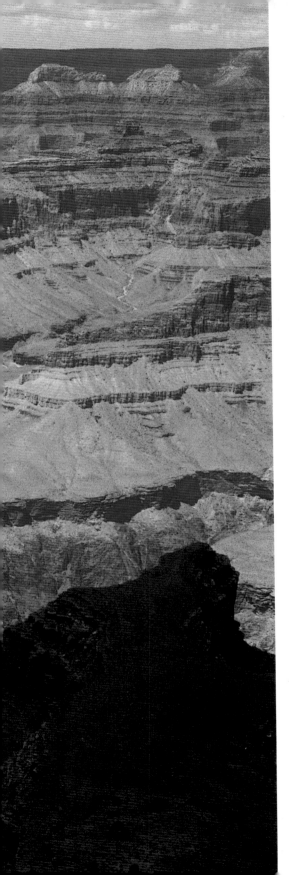

Hidden Water

SHARMAN APT RUSSELL

My heart starts beating fast when I first see the Grand Canyon, looking down from the South Rim, the vertigo of too much space. My bones feel hollow, like a bird's bones. My shoulders draw back in a vain effort to grow wings. The next day I start down the Bright Angel Trail through drop-dead gorgeous scenery which I barely notice because I am still, always, looking down, at my feet now in love with gravity. After eight miles, the trail curves—all innocence—and I see the Colorado River close and huge. Again my heart beats fast. Too much water. Jade-green, emerald-green, a green fist moving through rock. I know enough now to expect surprises.

View from South Rim overlooking Granite Rapid

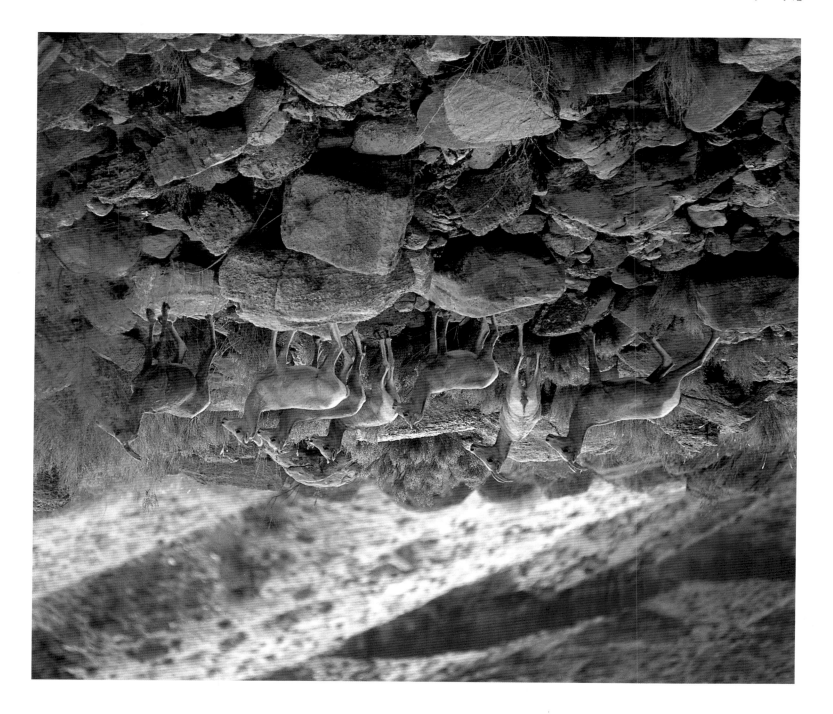

But, first, we are herd animals. I am joining twenty strangers for an eight-day, 100-mile oar trip. I will not experience the land or the river until I feel safe with these people, until I fit into the herd. So I learn where everyone is from—Wisconsin, New York, Tennessee, Washington—and what each one does for a living. I evaluate quickly who will be kind to me and who will be indifferent, making my alliances and truces. We all do this. With our small talk and with small gestures, we build what we need to become, a short-term tribe.

Floating the river, we learn that bighorn sheep are also social animals, the totem animal of these cliffs. Our orange rafts move cheerfully on the emerald water. "Bighorn sheep alert," someone calls from the orange raft ahead. A young ram drinks and lifts his heavy horns to stare. He thinks we are part of the scenery. Flattered, we watch him lower his head and drink again. Above, two ewes and their lambs browse on the fluorescent green of new grass. Above them, red cliffs block the sky.

Everything at the bottom of this canyon seems to be reaching toward the sky, except for the lizards who flash across the white beach sand and dive into the rocks. The lizards are often good for a surprise. A dull-gray chuckwalla reveals a scarlet neck. On the path to a spring, I hear the screech of a cicada end abruptly. I turn to see a collared lizard glaring at me from a rock ledge. The cicada is brutally suspended, half inside the lizard's mouth, its front legs kicking. The predator glares: Mine. The insect seems to look at me too.

Colors keep changing. Pink rock, purple rock, black rock, orange rock. One morning we wake to find that the green river has turned brown, runoff silt from Paria Creek. Two days later the brown we bathe in flows red from a flash flood on the Little Colorado. A red river carries us now, slapping us onto whitewater, teasing us into eddies, rising up in waves—twenty feet high—in the messy rapids called Hermit. A guide falls into the red river. Holding tight to his raft, a passenger dislocates his shoulder.

Rapids are dramatic. Fortunately, on this trip, they do not surprise me. It is on the long hikes up side canyons and drainages, as a land mammal, that I am most amazed.

Flirtatious and lush, lined with monkeyflowers and seep willow, Tapeats Creek runs through a prickly-pear desert. After a few miles, Thunder River, only a half mile long, pours suddenly into Tapeats Creek: a river into a creek, not a creek into a river. The rushing water comes from a hole in the wall of a red cliff, water thundering in a thirty-

For me, continuing to work in Grand Canyon as a river guide is about connecting. It's about connecting in a powerful way with my physical world by living in the canyon for two to three weeks. It's connecting with my own spiritual world there, where it is most clearly felt. It's connecting with strangers who become friends and sharing an experience that connects us forever. It's being part of the connecting of a group of people who become the trip, creating a life and direction if its own. It's there where all the parts of myself connect completely.

MARY WILLIAMS
River Guide

foot waterfall over a greeny profusion of ferns, mint, arrowweed, and cotton-woods. My river guide tells me that behind this red wall is a lake created by the seep of snow and rain through porous limestone. My guide tells me about her friends who have crawled through rocky passages into this hole in the red wall carrying inflatable kayaks which they used in the darkness to cross the secret lake. My guide tells me there are other lakes like this, floating above us, hidden water cupped in stone.

We go up Makatamiba Canyon with most of my rafting group inanely singing "Mat-kat-a-mi-ba" to the tune of "Guantanamera," a song, regrettably, that stays with me all day. We hike to Beaver Falls at Havasu. These blue-green pools might contain the meaning of my life. If I came here to live forever, bringing my husband and children and a few friends—ignoring completely all Park Service rules—I might find that deep happiness we associate with beauty.

Now someone from my group starts singing "Bali Ha'i" from the musical *South Pacific*. Laughing, we drag our culture behind us, a weight we must carry.

When I am most alert, I am most surprised. A peregrine falcon chases a raven. A cat-tail is too perfect to exist. In some places—at Thunder River, at Makatamiba—I have the astonishing desire to pray out loud, as though I believe in gods and spirits, in voices whispering, whispering all around me. There are landscapes so powerful they demand our prayer. The land does not need this. We need this.

High above, the massive sculpted rock faces never, ever, stop surprising. The speed and power of the green, brown, red river never, ever, stop surprising.

In the end, perhaps, what we remember best from a trip can be the most surprising thing of all. Months later, when I close my eyes and think of the Grand Canyon, I do not see the South Rim, that postcard image of space and matter. I do not even see the rushing Colorado River ahead and behind my orange raft, the whitecaps swirling. Instead I see a deep, black, still lake, hidden water, secret water behind the red wall. I see kayakers silently gliding in the darkness, lifting their paddles, moving through rock, moving like a prayer.

I see myself as one of them.

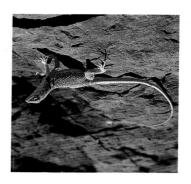

Collared lizard Opposite: *Thunder River*

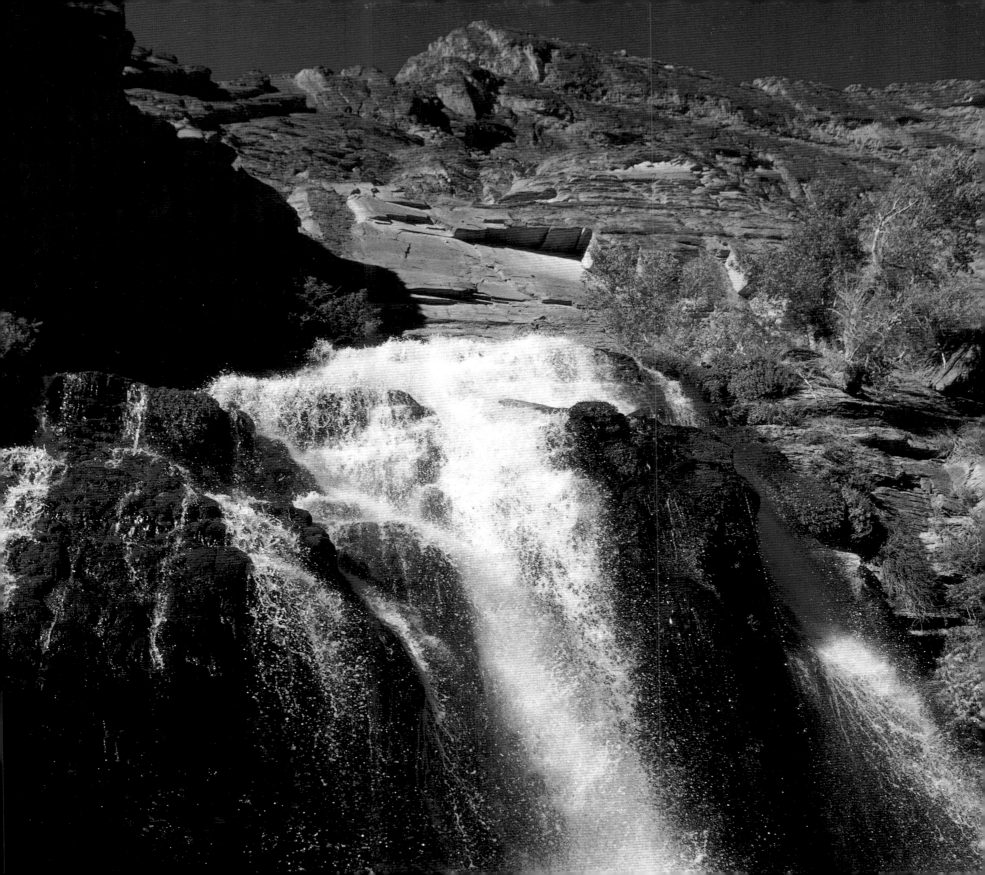

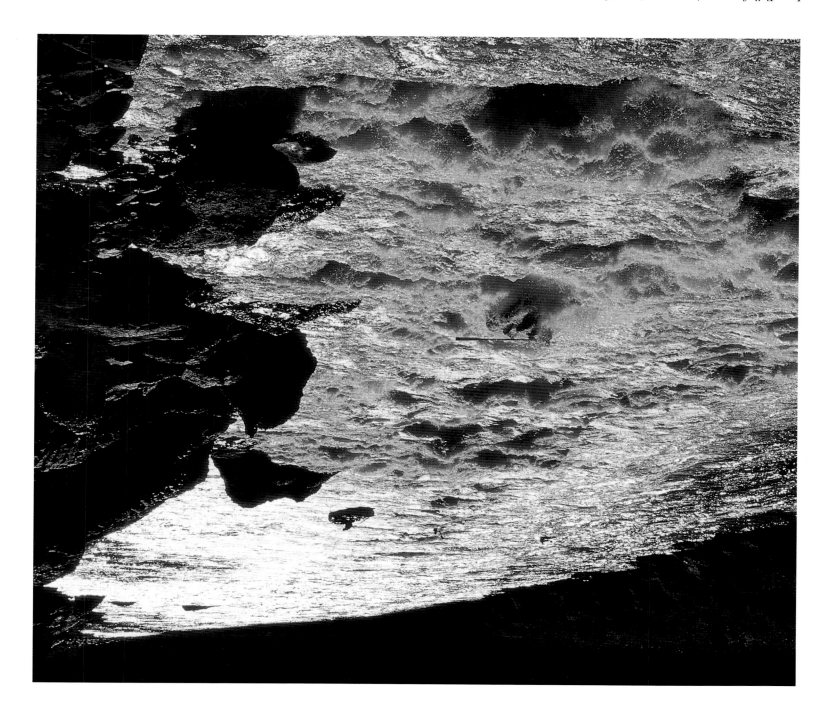

Faces of the Canyon

PAGE LAMBERT

"In the Canyon, you will hear the voices of our ancestors," whispered my only sister from her home on the Big Island of Hawaii. "The River will be a good place to grieve." Together we mourned our father's death. Together, we cried.

Our father had died at high noon on the spring equinox—when the sun was at its highest directly overhead, and day and night were everywhere the same—a time of earthly balance. Then Comet Hale-Bopp streaked across the sky, the earth moved between the moon and the sun, and our eclipsed world became a shadowed place.

Weeks later, I left my Wyoming ranch to be a crew assistant on a thirteen-day, 226-mile raft trip down the Colorado River. Envisioning hours of welcome solitude in which to grieve, I prepared myself to meet the twenty-three strangers with whom I would take this journey. My sister's words echoed in my mind: *You will hear the voices of our ancestors.* How far back must one go, I wondered, before a father becomes an ancestor? Eagerly, I ventured into this elemental place of earth, air, fire—and water.

Our four rafts and one paddleboat eased into the water at Lees Ferry. The Canyon introduced herself to us slowly, layer by layer, as her walls eased themselves higher into the blue sky. But the River came at us all at once, with Badger and Soap Creek Rapids, then harrowing House Rock and the Roaring Twenties.

With each rapid, the River batted her paws at us playfully, showing us just enough of her white-tipped claws to earn our respect.

We hiked the North Canyon, which led to a quiet pool surrounded by feminine swirls of curvaceous rock. The guides, as at home in this environment as the canyon tree frogs living within splashing distance, crawled the womblike walls spread-eagled, their grips sure and strong. At Stone Creek, Sue, the other assistant, and I braved the arduous hike and were rewarded with waterfalls, tropical greenery, and black collared lizards.

With each rapid, the River batted her paws at us playfully, showing us just enough of her white-tipped claws to earn our respect. Those in the paddleboat raised their paddles overhead in celebratory salutes, then slapped the River affectionately—teasing her, tempting her. The guides eased their oars through the water, moving toward the Great Unknown, while Sue stretched out her long, lean, muscled legs and smiled quietly.

One day two passengers, a brother and sister, along with family and friends, held a Yizkor ceremony in honor of their father, who had also just passed away. In a quiet circle, they said the Jewish Kaddish prayer. I stared up at the towering cliff faces and wished I could join the intimate service.

Instead, the words of the Lakota holy man, Black Elk, came to me. "You have noticed that the truth comes into this world with two faces. One face is sad with suffering, and the other laughs; but it is the same face, laughing or weeping. When people are already in despair, maybe the laughing face is better for them; and when they feel too good and are too sure of being safe, maybe the weeping face is better for them to see."* Would I now, after the despair of my father's death, finally see the face of laughter?

The River beckoned. Unable to resist her passionate nature, dangerous though it was, I turned away from the circle of prayer and eagerly began helping Sue and the men load the rafts.

Each ripple of whitewater brought a new adventure. Sockdolager Rapid bent Howie's boat in half and delivered a one-two punch to bloody his nose. Sue and I held hands while leaping twenty feet into the turquoise waters of the Little Colorado. Blue herons greeted us from the waters of Bright Angel Creek, while the big River, stalking the shores, flirted shamelessly—lapping her tongue at our ankles, batting at the bows of our boats, rocking us to sleep at night.

Wilderness, I began to realize, belonged not only to the landscape of the earth, but to the landscape of the mind as well.

We hiked silently up into the ribs of Blacktail Canyon and saw the Great Unconformity where the Tapeats sandstone and the Vishnu schist joined—a geological wonder of one billion years of missing rock. I traced my fingers over the layers, transcending the centuries, and thought of how, as my father lay dying, I had tried to smooth the lines of pain from his anguished face. Nature made it seem so easy—this going from one generation to the next. Perhaps this barrier of death separating father and daughter was not carved in stone as I had imagined.

The River, eyeing Howie at Specter, tossed him from his raft into the swirling rapids, then impishly stole one of his flip-flops. The mishap broke a small bone in his shoulder, disabling him. He tied the remaining sandal to the bow of his boat and, one-armed like Major Powell, tipped his straw hat, acknowledging the River's prowess.

Sue, who had rowed and paddled before but lacked Howie's years of experience, took

* *Black Elk Speaks*, by John G. Nahardt

Hedgehog cactus

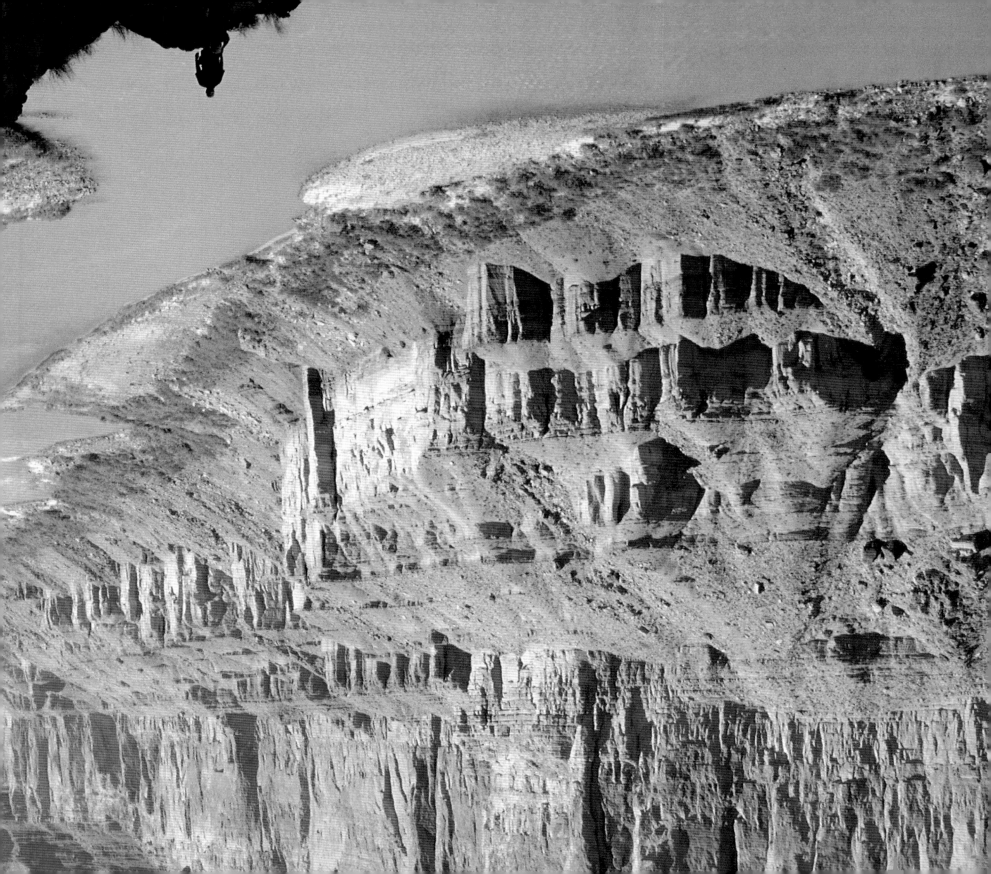

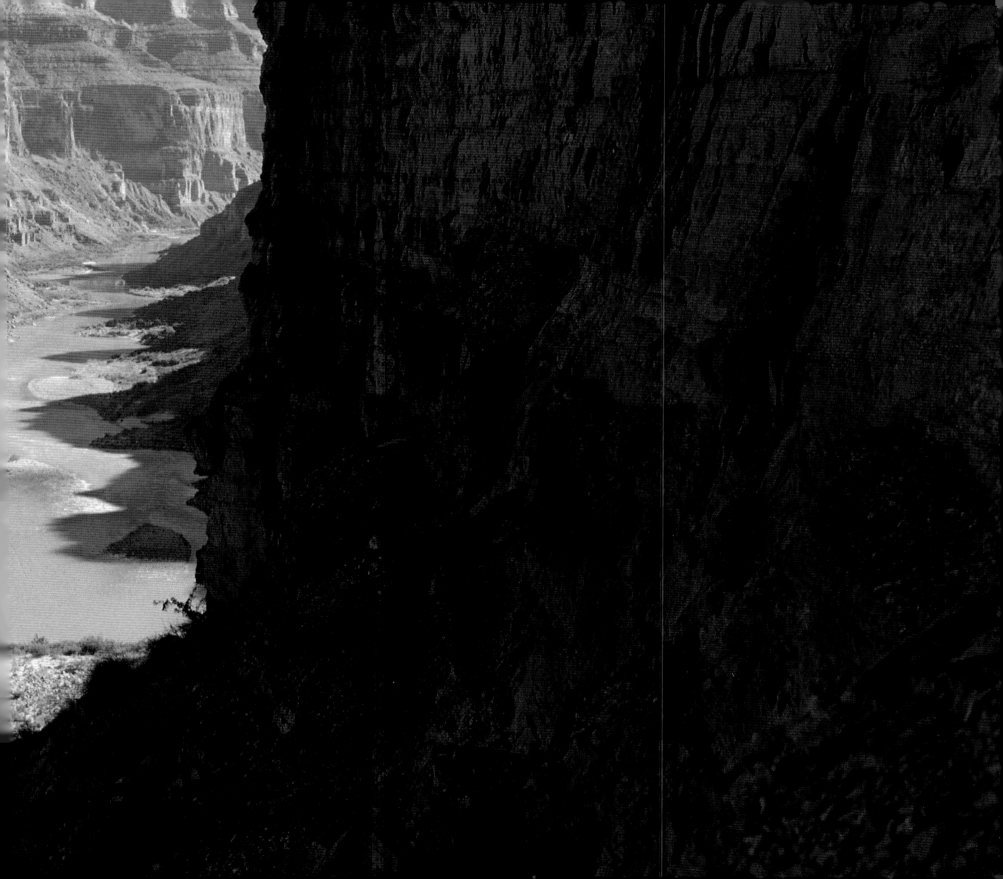

Previous page: *View downriver from Anasazi granaries at Nankoweap*

over for him at Deubendorff. He and I became her only riders and, with 95 miles left to go, she became the boatman.

Sue's rowing was capable, in control, and remarkably calm. When the hot, dry winds blew in her face, I poured buckets of cold water over her head. We laughed, enjoying the camaraderie of the Canyon. She avoided most of the energy-sucking eddies, and faced the rapids of Tapeats, Fishtail, and Upset with skill and enthusiasm. I envied her proficiency—felt proud to be a new friend. Yet the question paramount in Sue's mind, and everyone else's, spurred us on like a tailwind: "With the River running at nearly 28,000 cubic feet per second, will Sue row Lava Falls?"

Her husband, one of the guides, knew the dangers intimately; he had seen the first woman die at Lava twenty years ago. Here, at one of the most difficult stretches of runnable whitewater in North America, the River bares her fangs. They say there are two kinds of boatmen: those who have flipped, and those who will. Many have been humbled by Lava's ledge hole—a deep abyss of ravenous black water with waves bold enough to bury the burliest of boatmen.

After scouting the rapid from the hot, rocky shore, and quietly listening to the well-intentioned advice of the other guides, Sue made her decision. She would run it. A motorboat from another outfitter ran the rapid ahead of us, then took up a rescue position downstream.

Our raft was the last to go. The wind picked up, hotter than ever. The strong current carried us quickly out into the middle of the River, too far to the right. Sue rowed valiantly, pushing hard, every muscle straining as she tried to go left, where the smooth tongue could ease us past the gaping mouth and huge waves.

But the River had something else in mind. She dropped us into her ledge hole, folded the raft over the top of us, then snatched us to her—spitting the boat back into the air like a piece of gristle. She sucked us beneath the surface and, alone, I tumbled through the wet darkness, not knowing up from down. The water churned and frothed, as if salivating in anticipation. "Take a deep breath before you do Lava," I had been warned.

Then, perhaps accidentally, the River brought Sue and me together. Our heads collided and we clutched at one another's arms, all the while in the water's dangerous embrace. Like a young lioness unaware of her own strength, Lava toyed with us. We surfaced, coughing and sputtering, only to be thrust under the waves again and again.

Why Am I Here?

The smooth sandstone massages
my bare feet

as the limestone wraps
itself around me & permeates the
layers of my skin

I inhale the desert wind & it
ignites a fire in my soul—

The river flows with its gentle
wisdom and is tender only when I
allow myself to feel its currents &
respect its strength—

I am joyful—

I am open to life's lessons—
lessons of mind, body, soul & spirit

I am my most natural expression
and as I hear the
peregrine & canyon wren sing with
spirit, so too do I.

JULIE MUNGER
River Guide

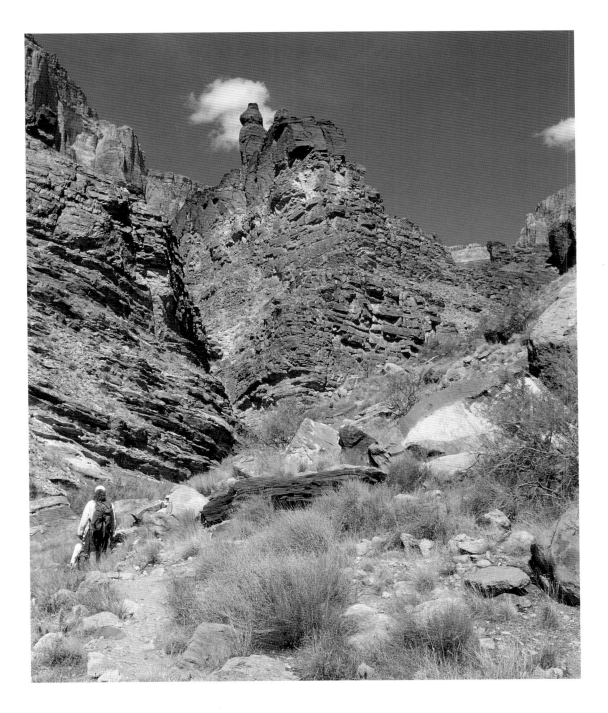

Hiking up Stone Creek

We clung to each other, not daring to let go. Finally, the River turned us loose. Rising to the surface—amazed, elated, and grateful—we looked at each other, and grinned.

Lava's own whitecapped grin eased into a contented Cheshire cat smile of smooth water. Only then did we notice Howie safely upstream clinging to the bottom of the raft, and the motorboat downstream screaming toward us, lifeline dragging through the water.

By that night we were laughing, drinking margaritas, eating steak, and Sue was, in everyone's mind but her own, a heroine.

The last evening on the River a radiant moon shone down, the wind eased up, and the air turned balmy—a bare-skin night full of promise. It was the eve of the summer solstice, when the sun sets in the northernmost corner of the sky, far from the celestial equator—when the night was as endless as the Canyon was grand.

I had expected the Canyon to be a hard and rocky place—abrupt, massive, and imposing. And so she was. I had not expected her to share with me her inner beauty: curvaceous streams, slick stone and green fern, waterfalls whispering in the shadows, pools glistening in quiet corners. The Canyon invited me into these places like a lover beckoning from afar. "Come," she enticed, "swim in the passionate river currents of my lifeblood. Lift the callused skin of my ancient body and glimpse the tender places of my soul."

This ancestral land of earth, air, fire, and water raised the twentieth century from my back and exposed layers of time, stacked one upon the other—Kaibab upon Toroweap upon Coconino. Yet her Great Unconformity freed me from the illusion of vertical time and space. My fingers caressed the ancient rock of the Vishnu schist, and once again I touched my father's face. And then, as I was taken back into the watery womb and thrust from it reborn, I heard my father's voice, joyous now, urging me on.

This ancestral land of earth, air, fire, and water raised the twentieth century from my back . . .

Julie Munger leads a group of passengers down the Little Colorado

"I am not

No Shit! There I Was...

LINDA ELLERBEE

supposed to be here."

It is, and I am, cold and damp. Gray sky. Wind. Don't know if it's raining, don't care. So much river water coming over my head, what's a little more wet? I could be in a warm, dry office in New York City, not crouched in a rubber boat (okay, raft), ankle-deep in 48-degree water, watching a bearded stranger row us down the Colorado River. We round a bend. Lees Ferry, our starting point for this journey, disappears. Two weeks? I am miserable.

"Bail," says the bearded stranger.

Twenty-four and one-half chilly miles later, we make first camp. As soon as I set up my tent, it blows up and away and might now be half the distance to Canada but for a big man who jumps into the air and catches it. George is from Covington, Georgia. Quit the navy at thirty-eight and figures if he lives frugally he won't need to look for a job until 2001. Meantime, George is seeing the country, having recently hiked all 2,162 miles of the Appalachian Trail. Now he's doing the canyon. Doing the river thing. I ask George if he's scared of the rapids. I am.

"Nah. You only live once."

Trite, but no less true for it. What is it I say when I talk about having had cancer? "Smell the flowers." "Take chances." "Live as if. . . ." I wonder: Do people know I might be lying? Right after I was diagnosed, right after I lost both my breasts and all my hair (my hair grew back), I did make time for flowers and chances. It was then I discovered the woods. Soon I came to believe this was a gift that had been waiting years for me, a Gulf Coast gal with a centrally air-conditioned past, washed ashore in the Northeast. I was nearly fifty when I began hiking and, later, backpacking, and whenever I would get to the top of something I thought I couldn't climb, I'd swell with pride and ask myself what other hills in my life might I now take on?

I am drawn to the woods by this challenge, and by solitude, but most of all by beauty. Every year, beauty becomes more important, some magic vitamin, a necessary tonic without which body and soul might wither. This is what the woods and, possibly, cancer have given me. But it's been five years. Life speeds up. Flowers are passed, unsmelled. Chances go untaken. That's partly why this trip appealed. Two hundred twenty-six miles of river. No telephone. No computer. Nothing but flowers and chances. I come to the canyon thinking of it as woods with no trees.

Yet I am frightened of the rapids, even before I see one.

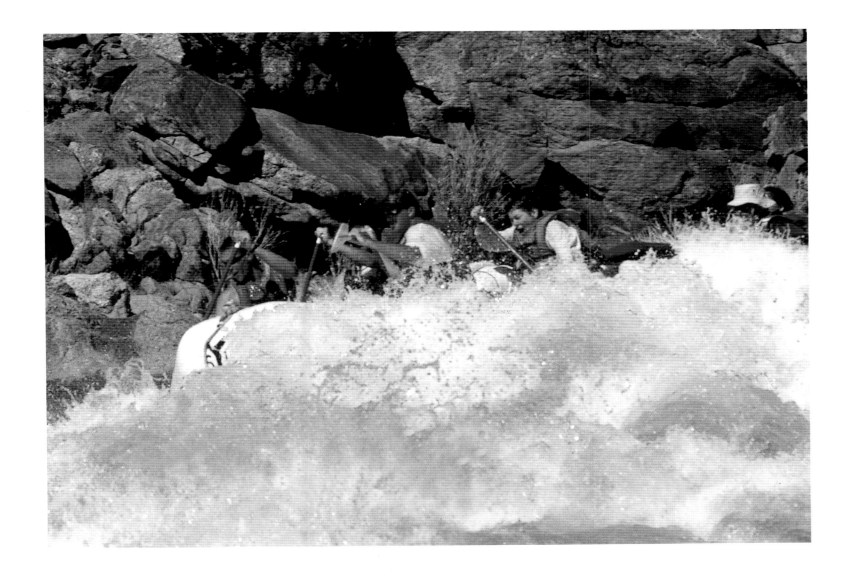

Linda Ellerbee paddling

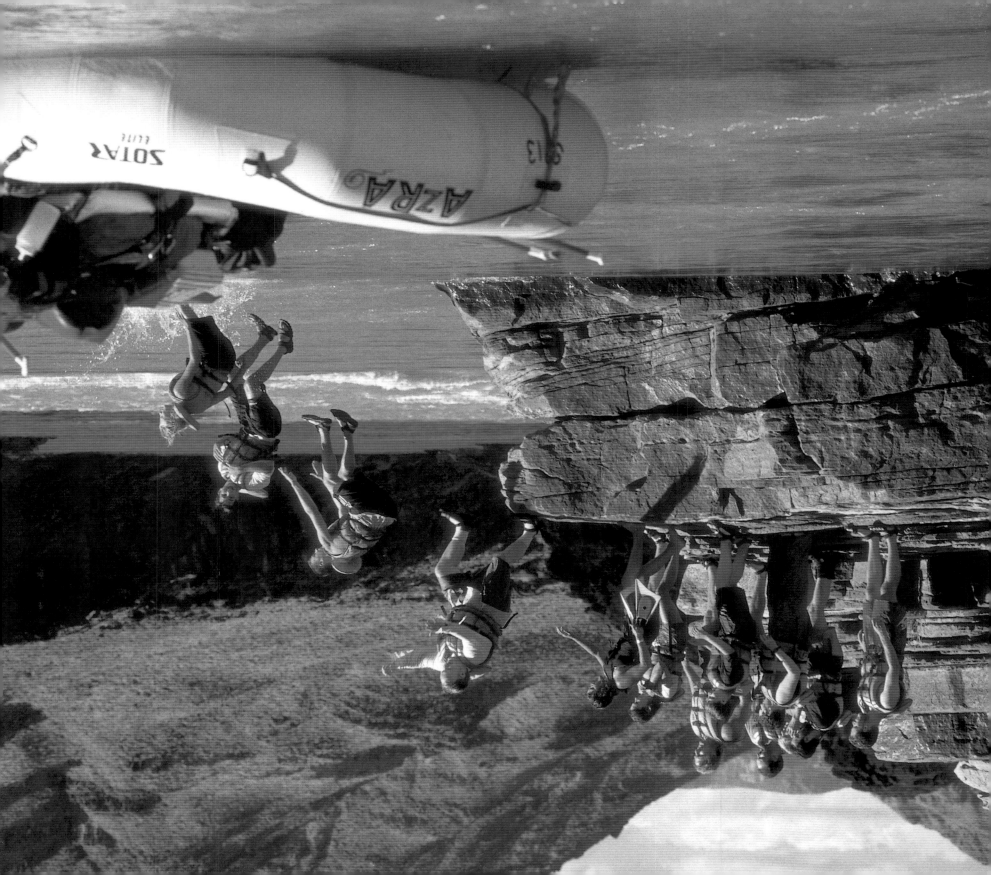

Today there was plenty of whitewater, although the rapids were not, I'm told, large ones. Rummaging in my gear, sorting through the too many things I've brought, trying (uselessly) to brush sand off my stuff, I remember the guy sitting across from me on the plane to Flagstaff. The back of his T-shirt read, "Face your fears. Live your dreams." Couldn't tell what was printed on the front; at the time, he was bent over, throwing up.

Make this rain stop. My shin is bandaged; I pulled a piece of the Cambrian Period down on it. Hurts, but I won't let on. I'm facing my fears, *okay?* All this talk about rock? Spectacular, but a little geology goes a long way. I'm more of a scenery junkie and the scenery is definitely being rained on. What did the boatman say? "The first day is the worst day."

I am not supposed to be here.

Two mornings later, someone asks if I would like to try the paddleboat. There are five boats. In four, the boatman rows while passengers, uncomfortably seated front and back, ride, talk, look about and hang on for dear life. In the fifth boat, six people paddle to the commands of a seventh, the paddle captain. Trouble with the paddleboat is there's nothing to hang on to, and you couldn't hang on anyway, because you have to paddle. You have to go through big hungry water, actually leaning out and shoving a stick into it at regular intervals. Counterintuitive, says someone. Suicidal, think I.

"Sure," I say. "I would like to try the paddleboat." (Checked the map; there are no giant rapids today.) Soon I'm reminded how much I like paddling, although until now the experience has been limited to canoes on quiet rivers and quieter lakes. We come to a small rapid. I manage to stay in the boat and keep my paddle in the water. I like the rush, want a bigger rapid. And then we are blessed. The rain stops. By noon, yellow sun dances on green water, bounces off red canyon walls, and shoots back up into blue sky. A crayon day. Feels like falling in love.

Takes a while for the river and canyon to grab hold. But they do. I wake in the night to catch the Big Dipper grinning like a Cheshire cat six feet above my head. *Gotcha.* Hours later, warm in my sleeping bag, the predawn air cool on my face, I say good-bye to the morning star.

On the fifth day, we hike up a side canyon, something we do every day, but this time I hallucinate. I hear Verdi. Another twist of the canyon and there, seated on bailing buckets, are four men, three with violins, one with cello, playing Verdi. Don't know

Passengers cooling off

who they are or how they got here. *Play on.* Verdi becomes Dvorak. Without warning, something inside is released. I begin to cry. So much beauty. So little time. *Canyon, fill me up.*

Our travels are not always the voyages of discovery we say we seek. Often they are rituals of reassurance. This was different. This required one to take physical and emotional chances. Not just the river. The people. *All these strangers? I'm supposed to get to know all these strangers? But isn't one of the gifts of travel the discovery of oneself* through other people?

At seventy-three, Wini is a retired professor and genuinely beautiful woman, smart and prickly. Does not suffer fools, period. This is her fourth trip down this river. One day, on a hike, Wini gets sick. Too much sun? Too little water? John, the trip leader, asks if she needs to be lifted out of the canyon by helicopter.

"No," says Wini, "I don't."

The subject is closed.

Next day, tired from being around too many people, I remain by the river when the others go hiking. Wini has also stayed behind. She stops by my camp, says she's come to realize this is the last time; she will never make this trip again. Since Wini is twenty-one years farther down the road, and because I very much want to know, I ask her what it is like to do something for the last time. I want to cry for Wini. For me, too. No matter what anyone tells you, there's nothing good about getting old.

At the moment, however, I've other worries. *Horn. Granite. Hermit. Crystal.* Bigger rapids. Bigger fears. "You can do it," says Julie, paddle captain and hero. You should see Julie. No matter where we sleep, she sleeps higher, curled up there somewhere, on some rock or another. Mornings, Julie comes down lightly, leaping from boulder to boulder, boat to boat, surefooted as any other wild creature. On the water, her voice is gentle, teaching us to paddle together, turning a group of inadequate paddlers into a team able to pass through a big rapid and come out thinking they've done it all themselves.

By now, I know the paddleboat is where I want to be. I love the thrill, love the paddling, and find it less frightening if I'm actually involved in my fate, rather than watching someone else row while I hang on and try not to notice a twelve-foot wall of water coming straight at me. But when we climb ahead to scout a big rapid and I look down into this bodacious breaking stuff, my stomach falls away like the rapid itself. *Oh, dear.*

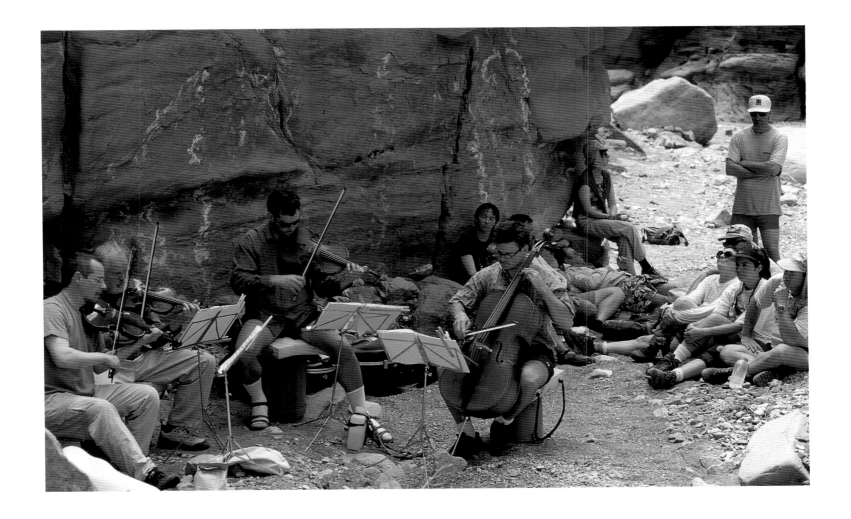

Left to right: *Steve Bryant, George Andrix, Arthur Bachman, and Peter Parthum of the Beau Quartet playing in Carbon Canyon*

God, don't make me paddle this! I can't. I will panic. Fall out. Die. Worse, I will chicken out. Drop my paddle and cling, sniveling, to the boat. I can't

Julie says I can.

I pray a secret prayer and, in case God can't hear me for the water, pray it again, louder. Thus begin the days of the big rapids. One boat flips, tossing its occupants into the current. They're pulled out downstream, shivering, teeth chattering, humbled. But our paddle raft shoots through the beautiful whitewater as though it were greased. We are triumphant. There are no words. Only the song inside me. I am my own band. And I am very much in tune. I, Linda Jane, have successfully paddled the biggest rapids of the grandest canyon of the Colorado River. I feel strong and competent and nineteen.

No. I feel strong and competent and fifty-two.

I am supposed to be here.

Can't wait to tell people back home about this. Julie asks if we know the difference between a fairy tale and a river story. We don't. "Well," she says, "a fairy tale begins, 'Once upon a time,' and a river story begins, 'No shit! There I was'"

Days of long play. Of water fights and waterfalls. Of skinny dipping, alone, in a turquoise pool, then napping in soft grass next to it. Of sun and sunrises. And sunsets. Of climbing boulders I once thought too tall. Of walking ledges I once thought too narrow. Of crude drawings on canyon walls, very old graffiti, left by ancient ones who disappeared. Nights littered with stars. Do the stars know where the people went?

One hot afternoon near the end of the trip, drifting toward more rapids, Julie tells us the reason we're a good paddle team is that we do what she says, when she says it. We nod in pompous agreement. Teacher's pets. "And that is why," says Julie, softly, "I want you to put down your paddles, jump in the river, and swim the next rapid."

"Excuse me? Have we not spent the better part of two weeks doing our best *not* to fall into this rock 'n' roll river with its cold, cold heart? Now you want us to go in *on purpose?"* But nobody says that. We're too busy putting down our paddles and jumping into the river.

Whooosh. Breath knocked right out of me. Whooosh. Don't forget to breathe out. That's what John said. Breathe in at the bottom of the trough. That's what Julie said. Swallowing green and swallowed by green. The world tumbles up and over. I see sky, water, sky, water, sky, water and then it's all one thing: skywater.

There are places in the world that you see with your eyes and there are those that you see with your heart. When you give your heart to such a place, there will be no taking it back. The Colorado River and Grand Canyon are that way for me. Certainly their beauty plays a part; there is nothing so lovely as seeing the canyon walls glow with bronze light at the end of the day, or watching the early morning river flow away from my boat like polished steel. But these are not the teachings that keep me coming back. I watch my guests learn the lessons of the river—to live on her terms, rediscover skills long forgotten or never attained, grow to be children again, comfortable on the land—and I learn it all again with them. We are reminded of our own humanity on the river. And we are restored.

CHRISTA SADLER
River Guide

The waves end. The ride is over. Julie hauls us into the raft. We are wet and slithery and loud: We are invincible. Soaked in beauty. We are alive.

Overcome with the pure joy of experience, I start thinking how great it would be to be a boatman (even women guides are called boatmen). How fine to live each day, mindful of the world immediately around you, focused on the river, the boat, the passengers, wet and dry, food and drink, sun and sand and sleep. Life 101. I'm about ready to quit my day job when Eric, a real boatman, points out a reality I've not considered. "Every year," says Eric, "I make less money. I'm sort of working toward a cash-free existence." Mmmm. Even that has a certain appeal. It is a life. A good one. But it is not my life. Not this time around.

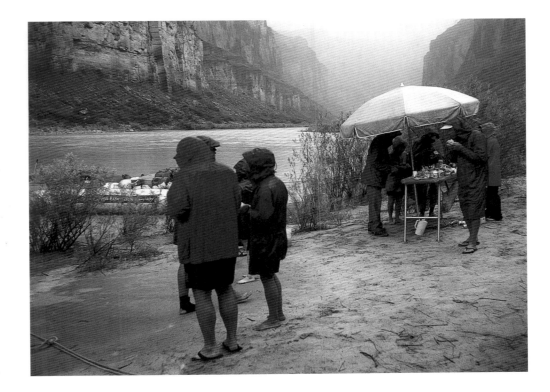

Weeks later, back in New York City, a phone rings. A woman, someone I wrote a story about, has died from breast cancer. It was the treatment that killed her. I celebrate her courage, mourn her death, and, sorry to say, am relieved it wasn't me. The fear is always there. Although I try to live as if the cancer were never coming back, I know all the nasty little numbers; half the women who get this disease are dead in ten years. I put down the phone, tuck away the fear, and go back to work.

But at night, lying in bed, troubled by death and overwhelmed by life, I find I can shut my eyes and whisper. That's all I have to do.

"Take me there," I whisper.

The magic begins. Gold light slides down a red canyon wall. A green river sings. I am a shining thing in a shining place, far from here.

Rainy lunch stop at Nankoweap

And I belong there.

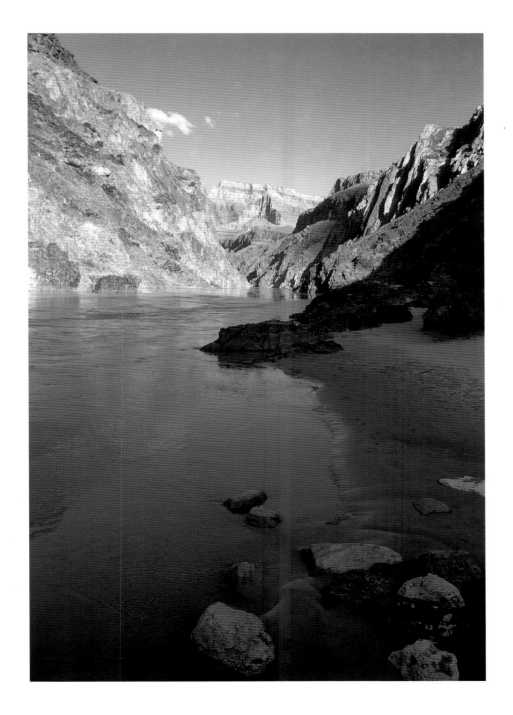

Granite Gorge below Hermit Rapid

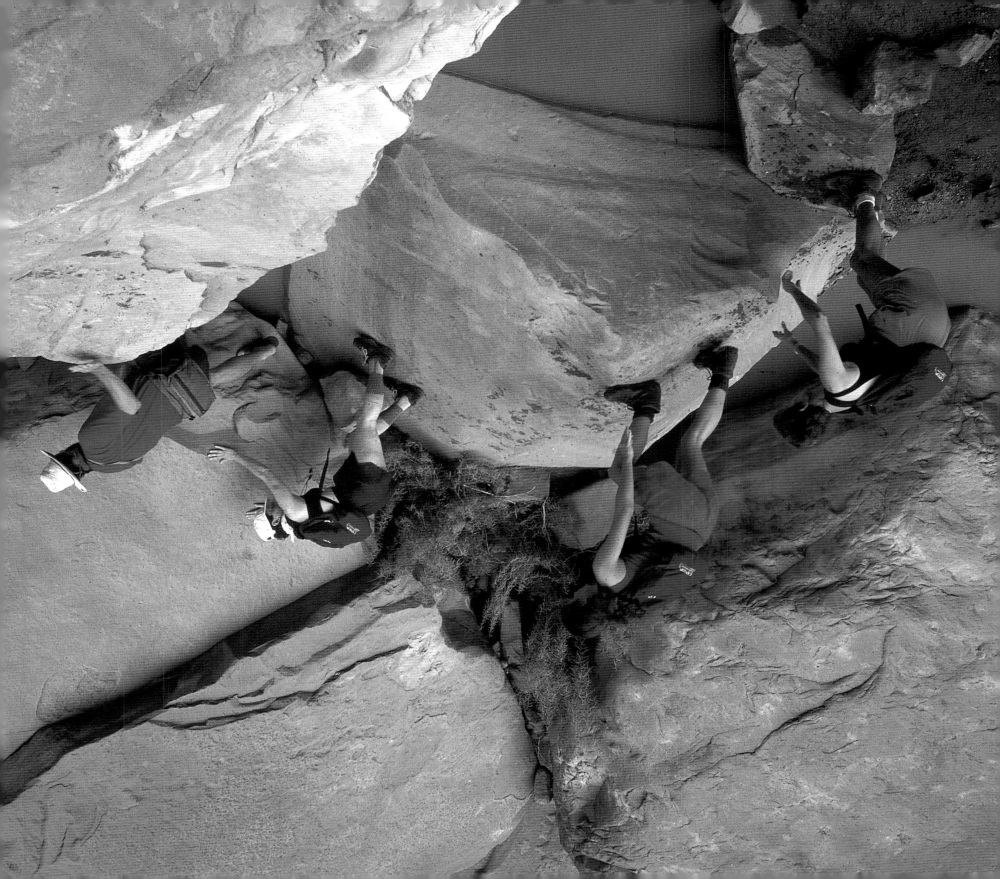

Dancing: A Grand Canyon Saga

EVELYN C. WHITE

It is 1:17 AM on the fourth day of my seven-day rafting trip in the Grand Canyon. I wake to recollections of Tina Turner's voice. *I left a good job in the city. Working for the man every night and day. And I never lost a minute of sleep worrying about the way things might have been. Big wheels keep on turning. Proud Mary keeps on burning. And we're rolling, rolling, rolling on a river.*

I sit up and lean forward in the blue and maroon tent that I have positioned flush with the roaring Colorado River. Careful not to wake the twenty-two other rafters who are sleeping nearby, I offer a quiet prayer of gratitude to my African ancestors. I thank them for bringing me, the only black person in our group, the spirit of Tina Turner: a free and talented black woman who rose triumphantly out of an abusive marriage to strut her stuff—on the thighs of a lifetime—all over the world.

Later, back at my home in northern California, I pull out my *Tina Turner Live* album (yes, album, not CD), put it on the turntable, and listen to her sing while gazing at concert photos of Tina performing in front of thousands of people. *This is the real deal for black women*, I think to myself as Tina and David Bowie erupt into the thundering funk of "Let's

Passengers scramble over rocks on a hike to North Canyon

"Dance." No limits. No restrictions. No chains.

Immediately, I'm transported back to the glistening stars that blanketed me in the Grand Canyon. There they'd be every night up against the black heavens. Infinite. Shining. Free.

My trip to the Grand Canyon was the most recent step I've taken in a decade-long quest to face my fears about the outdoors. In fact, I didn't realize the full significance of my journey until I found myself explaining, to the river guides, the complex, the psychological role water has played in the lives of most African-Americans. A well-trained, sensitive, and compassionate group of white women, the guides welcomed the opportunity to chat with me about the absence of blacks on rafting trips on the Colorado.

"Our ancestors were stolen from Africa and brought here on boats, usually packed on top of each other like sardines," I told Kim, Kelley, and Smitty. "During segregation we had to drink from 'colored' water fountains and weren't allowed to swim in public pools. A lot of lynched black people were fished out of rivers. Fire hoses were turned on us when we marched for freedom in the 1960s. Whether we're conscious of it or not, water holds a lot of wounding memories and imagery for black people."

The women look back at my brown-skinned, dreadlocked visage in a uniform composition of tan, auburn-haired silence. In their stunned amazement, I see acknowledgment of a never-considered truth. I feel exposed and vulnerable, but nonetheless grateful for a conversation about the emotional scars of racism that is long overdue. *White people need to know this,* I think to myself. *Black people need to speak so we can stop feeling so dispossessed from the sea, sky, and open plain.*

For after years of challenging myself to "get right" with Mother Nature, I've come to believe that it is primarily emotional barriers that are today preventing blacks from fully exploring the outdoors. The Jim Crow laws that degraded us and severely circumscribed our daily comings and goings have been abolished. The evil that once lurked in the wilderness in the form of bounty hunters and sheet-clad Klansmen has been assuaged. We are no longer chopping cotton under the blazing sun or trembling under the threat of being "sold down the river."

Thanks to the gains of the civil rights movement (we indeed survived those fire hoses and snarling dogs), a growing number of blacks have the income to afford adventures

"Mom, why can't you be normal?" my daughter asked one day as I sorted through my boating gear before a trip. Her question was formed in the mind of a twelve-year-old deeply mired in pursuit of peer acceptance; she demanded an answer.

I tried to explain my deep connection with the River and its community that have so enriched my life. Her question wasn't fully answered, though, until several years later when she experienced it herself. My parents introduced me to the Canyon; the opportunity for self-discovery the River provides is the greatest gift I can offer my children.

JERI LEDBETTER
River Guide and Past President of the
Grand Canyon River Guides

Rock squirrel

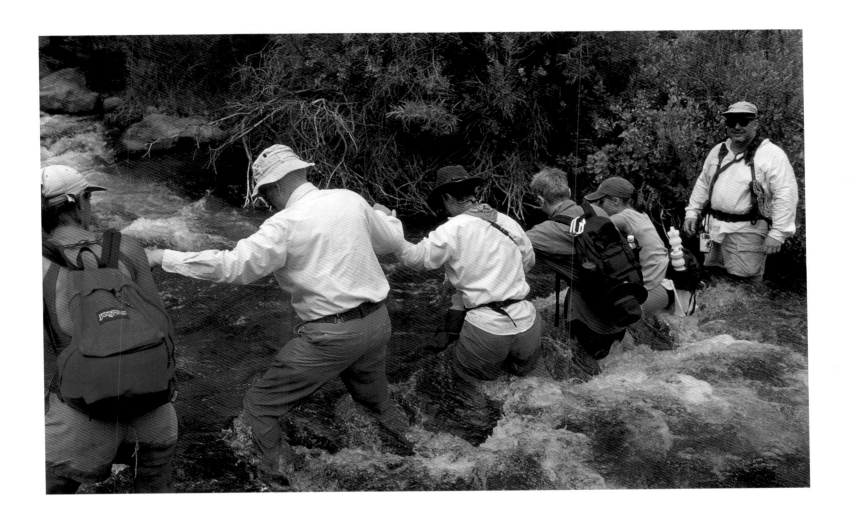

Passengers assist each other crossing Tapeats Creek

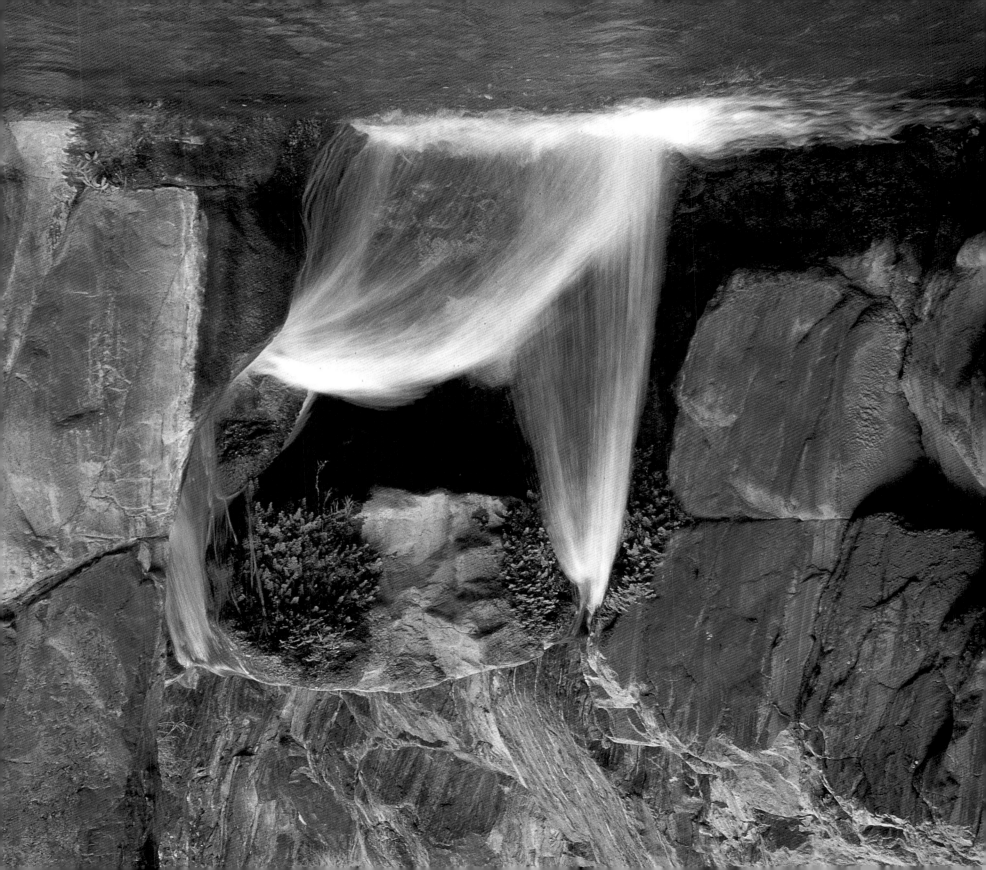

such as rafting or camping trips on the Colorado. To those who would disagree, I point
to the throngs of African-Americans who flock annually to luxury resorts in Jamaica,
the Bahamas, and other tropical isles in the Caribbean. Truth be told, most outdoor
trips cost less than vacations centered around fancy hotels, restaurants, and shopping
extravaganzas. So why is our presence in the Grand Canyon and other natural environs
so rare?

Perhaps a black man I crossed paths with at Havasu Falls best explains how the emo-
tional pains of racial oppression conspire with other elements of black life to prevent us
from finding a home in nature. "All the lessons we are taught in our families,
church, and community are about moving forward and getting ahead," he
said. "To come to the wilderness is to return to the primitive. Black people
don't see anything 'advanced' about sleeping outside or relieving themselves
in the woods."

Well, in the words of Patti LaBelle, I think it's time for black folk to "get
a new attitude." Especially for black women, who have far fewer opportuni-
ties for athletic endeavors than black men, the outdoors represents an
unparalleled source of bounty. When I wasn't taking an exhilarating romp
through the rapids on the big, *safe and secure*, blue boat, I was hiking, ford-
ing streams, being showered under spectacular waterfalls, hauling gear, and
being an all-around amazement to my heretofore nonphysical self.

And on the admittedly important issue of "mental duress," not once was I called out
of my name or disrespected in any way by anybody. On the contrary, my fellow rafters
were among the most considerate, sensitive, intelligent, interesting, fun-loving, and
helpful whitefolk I've ever met. As we say on the streets, "They could hang."

Thus, an already grand time in the Grand Canyon moved toward magnificence when
"the private dancer" found her way to me at midpoint. With her spirit song about
"Proud Mary," I felt as if Tina Turner had affirmed my adventure, that she'd given me a
sultry, sister nod to keep on rolling on the river.

And while my thigh muscles are a far cry from Tina's, I intend to continue giving
them a serious workout. See a black woman in a meadow, on a trail, in a raft, or scaling
a mountain, and it's likely to be me. Dancing in my own way. Triumphant in my own
growth. Trying to lift up my people to be truly free.

Opposite: *Clear Creek* Above: *Boatman Peter Ryan*

River Tao

BRENDA PETERSON

Water is the blood of the Earth, and flows through its muscles and veins. . . . It comes forth in metal and stone, and is concentrated in living creatures. Therefore it is said that water is something spiritual.

KUAN TZU

Passenger contemplates the river

I am still on the river. Every time I close my eyes, I return to drift down the Colorado River along its secret, swirling eddies and rock along its red, rolling rapids. Like destiny, this knowing river carves canyons, insists itself through bright granite, black-hard lava flow, and stone shale so old we cannot radiocarbon date it to tell an age.

Never in my life, except for my first five years raised on a Forest Service ranger station in the High Sierras, have I been so out of time, disconnected from daily communication with what we on the river simply called "up there." So deep were we in 1.7-billion-year-old rock that no cellular phones could signal satellites, no transistor radio could scale sheer stone, except one night a river runner announced, "Got a few seconds of radio news. Biggest crowds in Britain since V-E Day for Princess Di's funeral." We all murmured our softly detached sympathy. Then he added, "And Mother Teresa died, too." In silence we looked at each other. The soaring roar of the river seemed an appropriate response to the loss of two beloved caretakers of the human world. But this world seemed so far away, as did most every personal attachment—from grief to glory. We were simply *on the river*, fallen into a watery trance accompanied by cicada plainchant, the melodic call of canyon wren, the dinosaur caw of startled great blue heron, and twice the stealthy blue speed of a peregrine falcon.

"Give it to the river," someone murmured whenever anybody chatted too much about personal life or problems. Our lives before this canyon seemed so distant. "Not insignificant," sighed an older woman facing a fatal illness who found the Grand Canyon a fine place to contemplate eternity. Smiling, she stretched out along the silver

pontoons of our boat. "Meaningful, our own lives, sure. . . . but, well, we're *here* now."

"Paleozoic seas once here, too," our boatman Art said. We dubbed him Art-More-Than-Science for his rapids finesse. We joined him in companionable quiet, gazing up at million-year-old shellfish and plants fossilized like a hieroglyphic language scrawled in stone. Every day we descended deeper into geologic time, a nonhuman story of Bright Angel shale with its turquoise green, black, and coral strata like woven patterns in a Navajo blanket. We beheld billion-year-old jet-black Vishnu schist and pale crimson-purple Zoroaster granite, volcanic craters and petroglyphs. One hematite-scrawled petroglyph showed a scorpion and bighorn sheep, mother and child stick figures, a blazing sun—signs of a civilization ancient as the Hopis, who believe this Grand Canyon and river their sacred *sipapu*, or "navel of the universe."

At this swirling center where the Little Colorado runs into its namesake, we surfed a small rapid, our life jackets like diapers around our bottoms as the river carried us past boulders and holes. Muddy water streaming off our chilled bodies, we rose up like primeval Creatures of the Red Lagoon, birthed and baptized by river blood.

After a few days, my mind was clear and uncluttered, my body focused on tucking to take the next mighty rapid. This river so completely captured my imagination that, like one possessed, I saw myself as merely an imprint of rock and river—my streaked hair was striated, my skin cleansed and scoured with the red grit of sediment, my clothes changed chameleonlike into the desert camouflage of terra-cotta. Days blurred as we

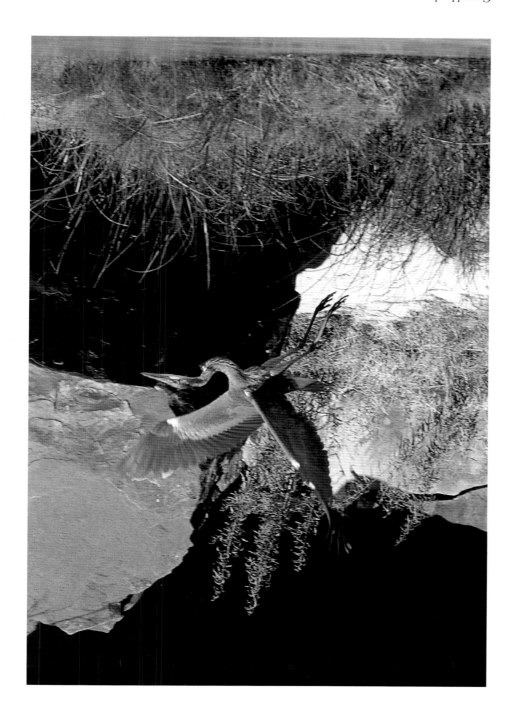

Great blue heron

drifted, studying our waterproof guides with miles marking each rapid like a sacred text of the river.

But at last I no longer glanced at my map to name "Specter" or "Hermit" rapids, to calculate the sheer drops or cite pioneers who'd made this trip a century before, paddling backward in wooden dories. I no longer needed to know where I was. I was on the river. My way and its way were the same. Some afternoons, lying back on the pontoons, I'd read the only book I brought with me—the *Tao Te Ching* in a new version by Ursula LeGuin. The *Tao* has always been my spiritual guide. As I floated, studying these 2,500-year-old epiphanies, surrounded by more enduring stone, I understood why Lao Tzu claimed water as his spiritual teacher and water's way as the "Way of Heaven."

"True goodness is like water," Lao Tzu wrote. "Water's good for everything." In this Grand Canyon, nothing lives without water and the river is its greatest nourishment. With its rich sediment, the river nourishes all it touches. As we flowed into a deeper oneness with this river *tao*, I felt its strength and goodness. I also felt something which I didn't understand, something unsettling and wrong. Every day the river rose or fell as if with a tide. Living in Seattle on Puget Sound, I am used to orienting and stabilizing myself by the ebb and flow of an inland sea. All life is dependent upon this daily sea change—an authentic and natural cycle of moon, waves, and tide. But in my own body, made up mostly of water, I recognized what made this Colorado River rise and fall was not at all natural.

When I asked boatman Dave Spillman about the strange rhythm, he sighed, "Upriver the Glen Canyon Dam manipulates the flow of the Colorado to make hydropower for cities like L.A., Phoenix, and Las Vegas. For three-and-a-half years the Bureau of Wreck the Nation poured concrete to block this river. That was 1963, and what do we have now? Glen Canyon flooded, but the natural, cleansing floods are gone. Water temperatures used to be warm as 85 degrees, now they've plunged down to 46 degrees so that native fish species are going extinct. And each water droplet is spoken for seventeen times over all the way down until this great river is just a trickle into the Gulf of Mexico."

"All dams die out," a German woman said. "They're made to last 50 to 150 years—a blip in geologic time." A scientist, she further explained that dams fill up with so much sediment a river simply chokes on its unflushed siltation. She nodded to my water-soaked *Tao Te Ching*. "And have you heard the Chinese are constructing the most powerful dam

ever built on the Yangtze River? That huge dam will flood the Three Gorges—ravines that are as famous in China as this Grand Canyon. I wonder, what would Lao Tzu say about his countrymen's ambition? The Chinese compare their dam to building the Great Wall. And, like we used to, they see the dam as a monument to their own greatness."

She finished sadly, "All for electricity. All for power."

The next day finding land, shade, and solitude in the moist mist off Deer Creek Falls, I read Lao Tzu's words: "Power is goodness. . . . Power is trust." "Power," he seems to say, has little to do with worldly achievement or ambition. I wondered about our human needs, both for worldly power and electricity. Long before the discovery of man-made electricity, Lao Tzu knew that water equals power. He also knew that worldly power and control were illusions. He could not have known that centuries later we would dam up rivers, creating artificial power to run our daily lives. What happens to power when we mistake it for our own and don't honor the water source from which it is borrowed? What within us is illuminated, when we only light up a room, a city, a night desert— and not our own souls?

Lao Tzu says truly wise people are "the light that does not shine." There is nothing artificial or falsely bright about true power, just as there is a world of difference between Las Vegas neon and authentic starlight. The river reminds us that water is the Way, not anything as recent as human evolution. When we interfere and change the rightful flow of rivers, we spiritually violate the earth's own body and blood, as well as our own. For we are made of water and clay; our bodies are first formed afloat in water's womb and buried in earth's.

At Deer Creek Falls, I listened to the thunder of clear blue water gushing hundreds of feet in a luminous freefall. This cascading wave shook the ground and yet its flow fed hanging primeval ferns; rivulets fell so delicately that they didn't disturb a yellow butterfly clinging to the crimson monkeyflower that climbed up its slick stone. Here was the wild, natural flow of water, and its power was humbling. I also felt a sadness well up in me and an almost unbearable sense of loss. The river was once warm, now it is cold. The river's natural cycle of floods no longer enriches the waters with enough nutrients like calcium, phosphorous, and bicarbonate, which nourish native plants and animals. This Colorado, which for millions of years has shaped worlds of rock and river, is now being shaped by us—and we really don't know what we are doing or what are

This Body of Water

This body of water—my body of water,
Rock, desert, wind—bone, sinew, breath.

The River,
Streams of sensation,
My feeling river running through this core.

Gently, with incredible force,
Lithe, muscular, sensuous,
Erodes,
Cutting through, slicing into essence.

The pleasantries,
The small talk,
Stripping away the superfluous,
Her will undeniable.

I put my feet in, reluctant at first,
Testing the water,
Then submerge.

Inch by inch,
Molecule meets molecule,
I am carried away,
Transformed.

Bone melts into molten silk,
I am becoming the river—
intent on the sea.

JAYNE LEE
River Guide

the long-term consequences of all our river changes.

All the boatmen had talked about the artificial flood of April 1996 in which the dam was opened up for a "spike flow"—a scientific experiment to mimic nature's rejuvenating floods. Much was learned, and there were many benefits from the artificial flood. Periodic floods may be needed in the future to support the river. There are still so many questions about how to honor the river itself and assure the health of the canyon ecosystem. Before it belongs to any cities or peoples downstream, the Colorado belongs to itself.

I grieve for this great river and I am deeply concerned about its well-being, its health and future. For while we have claimed the river for our own, we do not have water's wisdom or way of knowing what is best for the river. Though we control the Colorado and have made it the hardest-working river in the world, we have not yet controlled ourselves enough to restore a fraction of what we've taken. So the Colorado which gives life to the West is itself deeply depleted. Even our river rafting trip, I realized, was owed to those who control the river. What would I give back? I wondered.

"You were asking about the dam," someone startled me from my reverie. "People are talking now about draining Lake Powell and restoring the Colorado River. Did you hear what that Sierra Club guy said? 'I don't want to be known as part of the generation that killed the Grand Canyon.'"

I agreed. "In my home, they've just voted to tear down the Elwha Dam and restore the river and its native salmon runs."

"There's some hope," she said.

I lay back, letting the waterfall thunder through my body. "Well," I sighed and stared up at the true power and greatness of this wild, world-changing water. Deer Creek Falls rocked the earth like a cradle. "Let's take the long view. Dams die out."

"So do rivers."

Sitting cross-legged a respectful distance from me, my river-running companion lay back and gazed up at the waterfall for a long time. Then she saw my waterlogged *Tao Te Ching* and closed her eyes. "Read something old as rock," she said.

Mist swirled around us as I found my favorite passage, "Water and Stone." I read it both as requiem and praise, as devotion and what I hope is destiny.

What's softest in the world
rushes and runs
over what's hardest in the world.

River running over stone, over dam, over millennia. River running true—to its story, to itself. May we be true as this river so that one day it is free to rise and fall with its own mystery, its Water Way.

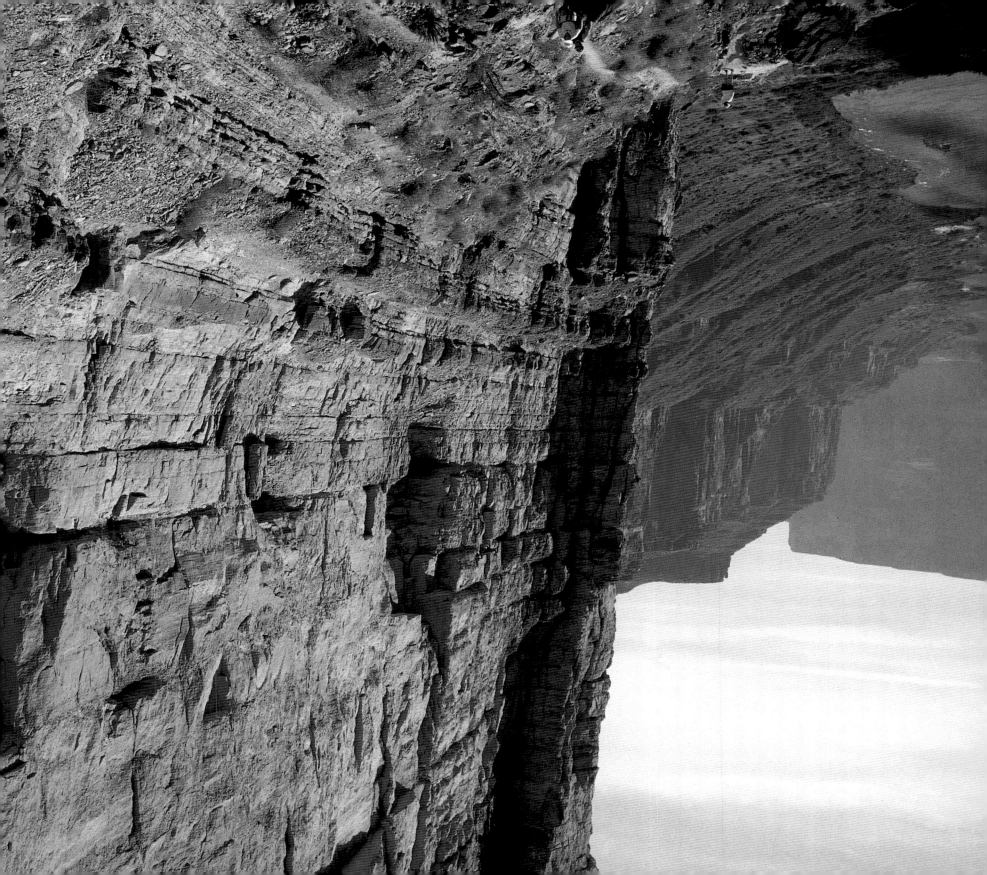

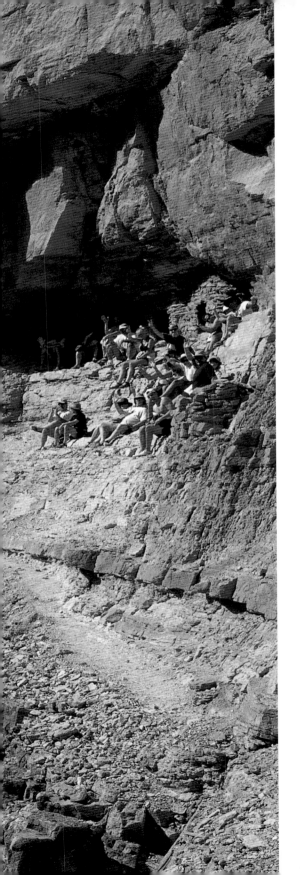

The Time It Takes Falling Things to Land

JUDITH FREEMAN

WHEN I WAS A CHILD GROWING UP

IN NORTHERN UTAH, MY FAMILY USED

TO TAKE A VACATION EVERY SUMMER

AROUND THE FOURTH OF JULY.

Passengers admire view from Anasazi granaries at Nankoweap

We'd pack up the car and head for my grandparents' house in Arizona, a destination that never varied. Our route took us down the old Highway 89, past the Big Rock Candy Mountain and Bryce and Zion Canyons, into Kanab and up through the Kaibab Forest, into the high plateau country of northern Arizona and, eventually, to the Colorado River.

Every year when we came to Navajo Bridge, which crossed the Colorado, we'd enact a little ritual. My father would stop the car and everyone would get out, all eight kids and two adults, and look for a rock, the bigger the better. Then, holding our rocks, we would walk single file out to the middle of the narrow little bridge and look down over the railing—down a terrifying distance to the canyon bottom where the river ran in a thin little ribbon of green.

As we stood there above the abyss—my family clustered together into a constellation of tiny figures dwarfed by the landscape surrounding us—the wind blew against us with an unsettling force. I felt so small before a canyon so large. I could never imagine actually descending to its bottom, though I often dreamed of doing so. What was it like down there? For a long while, we'd simply stand there on the bridge, held silent by the view. And then eventually we'd do the thing we'd come to do, and one by one we'd let our rocks drop and measure the time it took for falling things to land.

All this happened a long time ago, and in that time almost everything has changed. My parents are now gone, mourned by their children who've moved far from their old home. The river from the north no longer runs free, but is regulated by a massive dam. Even the old Navajo Bridge is now closed, except to foot traffic. And now, nearly forty years later, I have come to the Canyon again to begin a journey I've never made before.

The first afternoon on the Colorado, as we floated silently beneath Navajo Bridge, I looked up and thought of all those times as a child when I had stood there with my family. The child looking down was now the woman gazing up, and I realized it was I who had finally landed, here in this place where I'd always wanted to be.

That night I made my bed on a narrow rock ledge above the river and gazed out at white-throated swifts skimming the water in the dusky, violet light, and I asked myself this question: What is it we seek in the wilderness, in these old and pure places? I thought of Edward Abbey and *Desert Solitaire:*

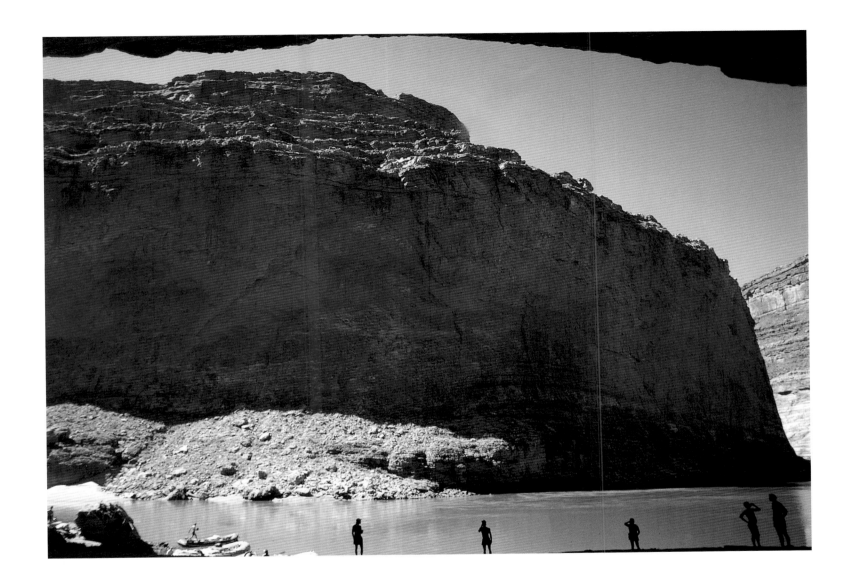

Looking out from Redwall Cavern

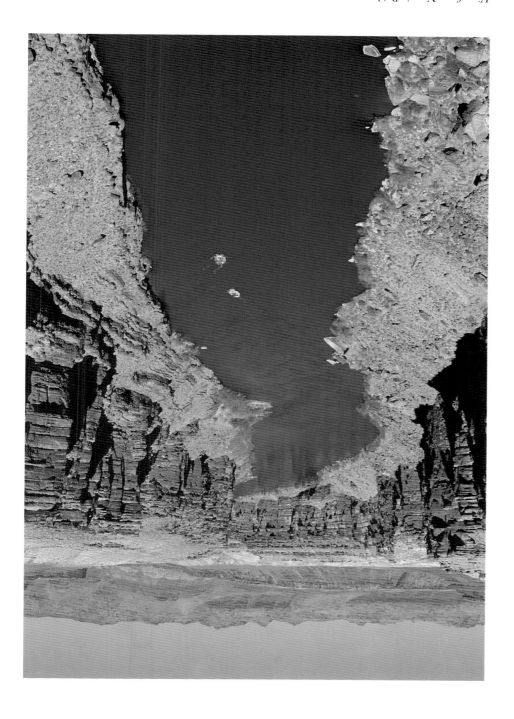

View from Navajo Bridge

I am here not only to evade for a while the clamor and filth and confusion of the cultural apparatus but also to confront, immediately and directly if it's possible, the bare bones of existence, the elemental and fundamental, the bedrock which sustains us.

Like Abbey, I, too, have dreamed of finding a place where "the naked self," as he called it, could merge with a nonhuman world. For half of the year I live in a city where there are no stars visible at night: The air and water are polluted and the local river is trapped in concrete. I've never slept under the stars for fifteen nights in a row. The idea of working my way, rapid by rapid, almost 230 miles down a river as mighty as the Colorado both frightened and excited me.

Yet there was this to consider: In nature one finds a sense of that "continuous present" of which Abbey and the Zen masters speak. If a single moment could be seen complete, might it not disclose the whole? This is what I felt the Canyon might offer me: a sense of being continuously present in a world that seemed gloriously whole.

A few nights later, I watched the full moon rise, the light falling on the cliff across the river from where I had spread out my bedding on a little spit of sand. To my back there was a small pool of water, trapped in a shallow basin. The pool was filled with singing frogs. I crossed the spit and stood at the pool's edge and, using my flashlight, peered into the water at a pair of mating frogs, swimming together, one atop the other.

Everywhere, I thought, the frogs are falling silent. Yet here they are singing. Bats filled the evening air, darting drunkenly, as if released from some nether part of the world to soar on leather wings, and at the moment some part of me soared with them.

As much as I loved the days on the river, the thrill of running rapids in the little paddleboats, it was our daily hikes up the side canyons that gave me the deepest feeling for the Canyon. One day, in withering heat, we hiked to a ridge a thousand feet above the river and I looked out across the gorge, beyond the pine-covered rims to distant blue peaks, as if I were graced with the vision of a bird. Later, we walked up a canyon and ate lunch beside a cool waterfall near ancient pictographs—red handprints left on a pale wall. Everyone who makes this journey down the Canyon adds their names to the unwritten roster of stone, those who can say *We came, we traveled these waters, we're among the privileged to have visited this place.*

A friend, who knows the river well, said to me before I left for my trip, "When you come to the Little Colorado, hike up its banks and you'll find a mud as smooth as chocolate mousse. Cover yourself in it and bake in the sun until it dries. Then crack your shell and wash in the river. You'll know what it feels like to be reborn."

I did as she advised. The mud was bluish in color and spread easily on the skin. As it dried, I watched myself become reptilian, scaled like a creature from another time. Then I washed in the river and laid against the warmth of a rock in the middle of the Little Colorado. I closed my eyes, and began to travel through time. I felt myself encased in an orange light, as if trapped in the oldest rock, far beneath the river. And then slowly I began to rise, up, up through the watery blue depths until I broke the surface and opened my eyes to the yellow sun above.

According to Hopi legends, the ancestral Hopis passed through a succession of worlds within the interior of the earth, eventually emerging onto the surface through Sipapu, a travertine spring in the Little Colorado River Canyon. I didn't learn this until much later, long after I'd made my own journey through the layers of Time.

For many nights after I left the river I awoke in darkness with the feeling I was still in the Canyon. I sat up suddenly in strange beds, in desert motels and distant cities, certain that I was still sleeping on a rock ledge or a spit of sand. I dared not move until I got my bearings. The slit of light coming from between a parting in motel curtains appeared to be the moon shining through a chasm of rock, and I thought, *How do I get to the river from here?* I wanted to be where I was not, and so I dreamed myself there, landing gently again beside the flowing waters, in the Canyon that was now deep inside of me.

Ocotillo

MARTHA CLARK
River Guide

I like waking up when it's light, going to sleep beneath stars, cowboy coffee, river voice, and the smell of thick muddy water, I like all the laughter, my partners, and the excitement of people who are there for the first time in their lives. I'm drawn to life reduced to such simplicity, such comprehensible terms. I love being immersed in the phenomenal beauty and intensity. I feel awed and comforted and very alive. The canyon is my friend and lover, teacher, inspiration, and challenge. I go home there and feel this unquenchable appetite for life.

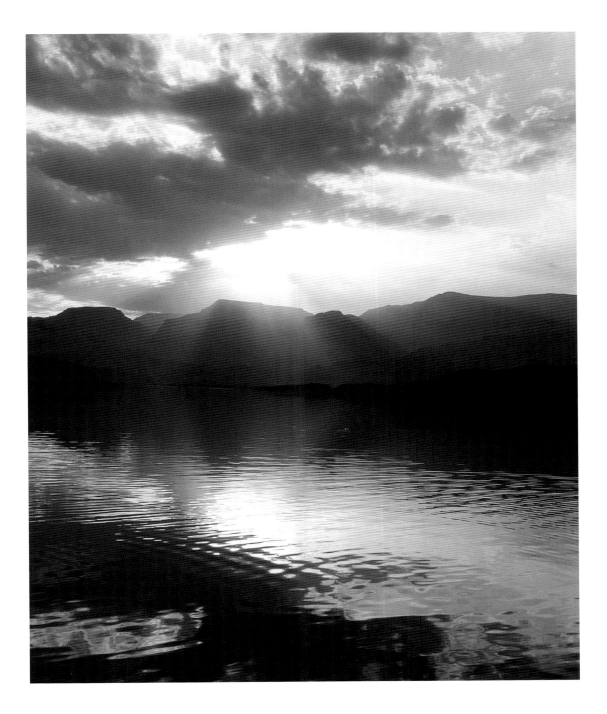

Sunrise at Pierce Ferry

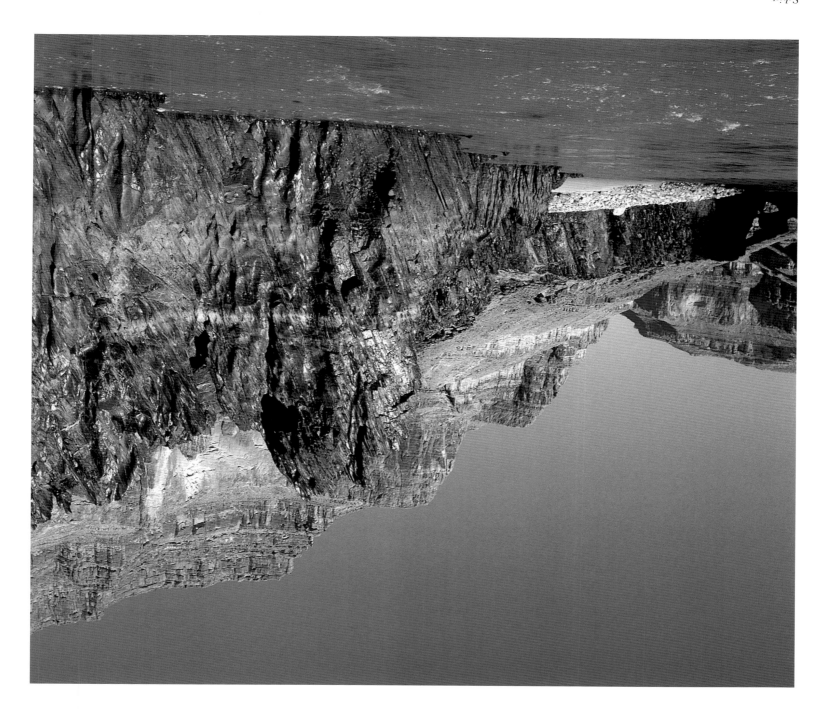

Of Walls and Time

R U T H K I R K

PEOPLE SAY THE
GRAND CANYON
MAKES YOU FEEL
HUMBLE, FEEL SMALL.
YOU'RE NOTHING
COMPARED TO SO
MUCH NATURE.
BUT I'VE KNOWN
THAT FOR DECADES.

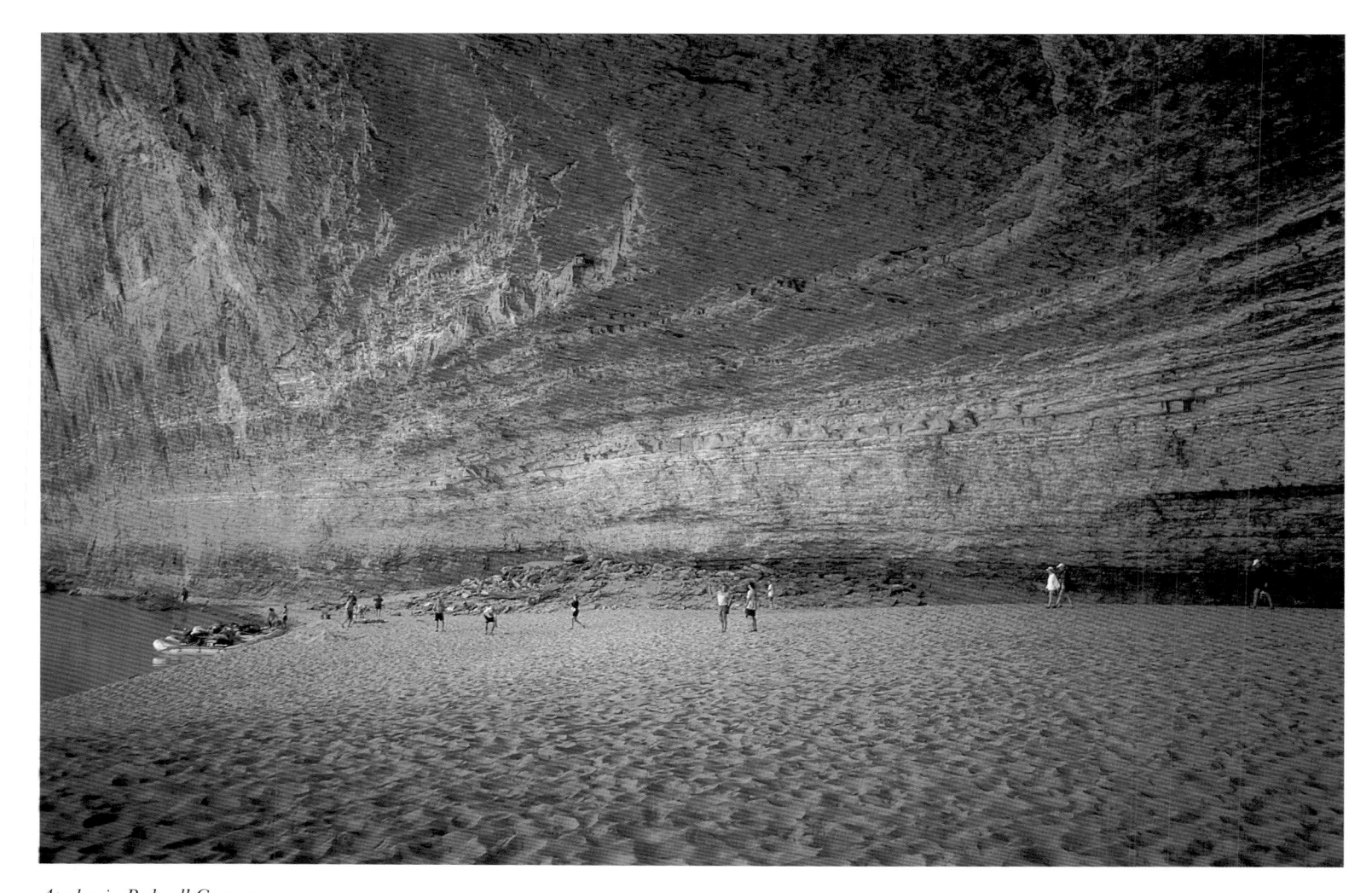

At play in Redwall Cavern

"WHAT WALLS BESIDES THESE

HAVE YOU KNOWN AND LOVED?"

What I feel is exultation, not humility. All that's needed amid the rock and the silence is to hear a canyon wren sing, surely a proclamation of more than real estate, or to fill eyes and soul with the unending colors and forms of canyon walls. It's easy to slip into river life without clocks or parking lots or decisions beyond how far up a side canyon to hike. "My grin is coming back," says businessman Herb, and he hurls water from our bail bucket onto the raft behind us. Boatman Ben wears his giant sombrero, lounges against a duffel bag, and rows the supply raft with his feet.

What puzzles me is why floating this river should be so compelling. I have known awe elsewhere, sensed other shivers of reverence dance along my spine. Why now is the canyon living up to its reputation? What is its magic?

Maybe the walls are an answer.

I ask raft mates, "What walls besides these have you known and loved?" Yosemite is obvious. Not obvious but equally wondrous is the waterfall-laced vertical rock of Desolation Sound along the central coast of British Columbia and, 200 pristine miles farther north, the soaring, glaciated, white, granite walls of the densely forested Kitlope river valley. In Alaska, there's the magnificent instability of Glacier Bay's blue-white ice walls calving icebergs into tidewater. And we add walls made by people. "Those of Cornwall," someone suggests. "So many stones—and with flowers!" Or the walls of Old Jerusalem. Or of Ryoangi, Kyoto's classic Zen gravel garden, where walls block out distraction and thereby free the mind to heed the scene immediately at hand. Is this what happens in the canyon? Do profound experiences require boundaries?

Or do Grand Canyon walls command eye, heart, mind, and spirit because they extend so far, soar so high, cut so deep? We will float for 277 miles, part of the way a vertical mile within the earth, all of the way aware of the contrast between river and rim: Down-Here rather than Up-There. On the river, awe feels almost manageable; the walls define and limit what the soul seeks to comprehend. At the canyon rim, scale and sweep are *too* grand; they overwhelm.

I prefer Down-Here. Yet it was while Up-There half a century ago that my husband and I set our life's course. World War II was newly over. We had two small sons. We were G.I.-ing through college. And gazing into the canyon we wondered how to join the National Park Service. The outcome was our calling as home parks such as Death Valley, Mount Rainier, and Olympic. We hiked and canoed and sailed.

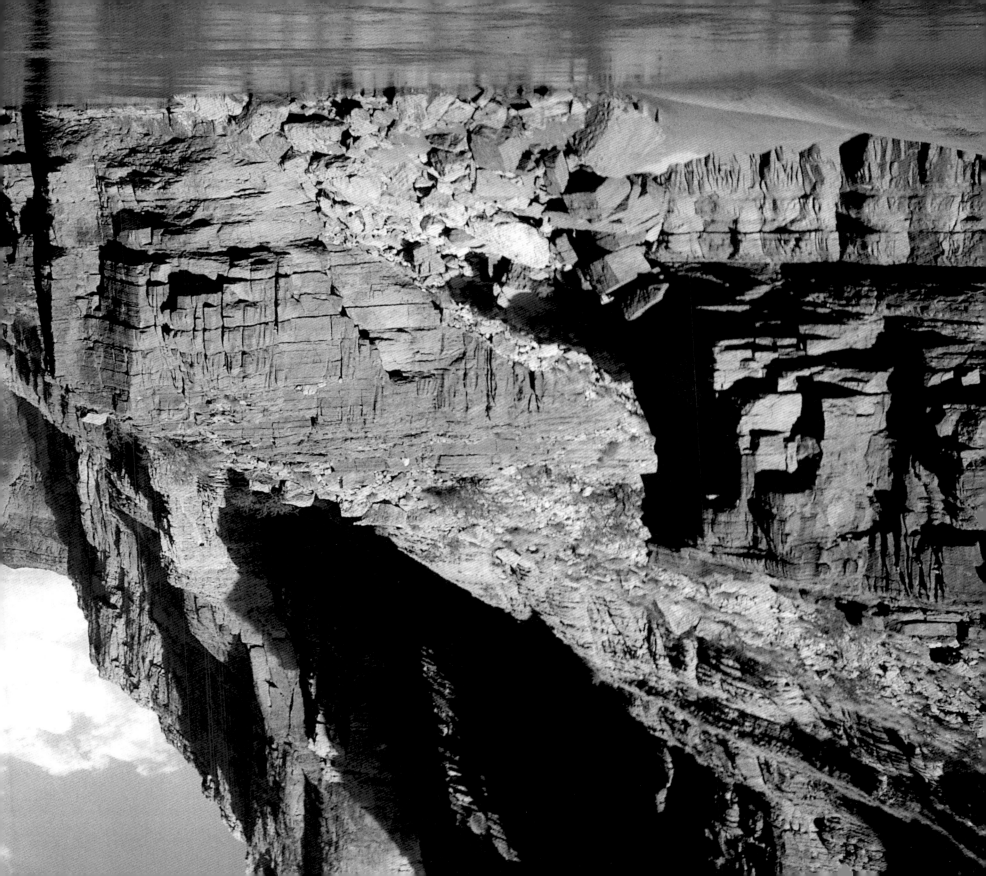

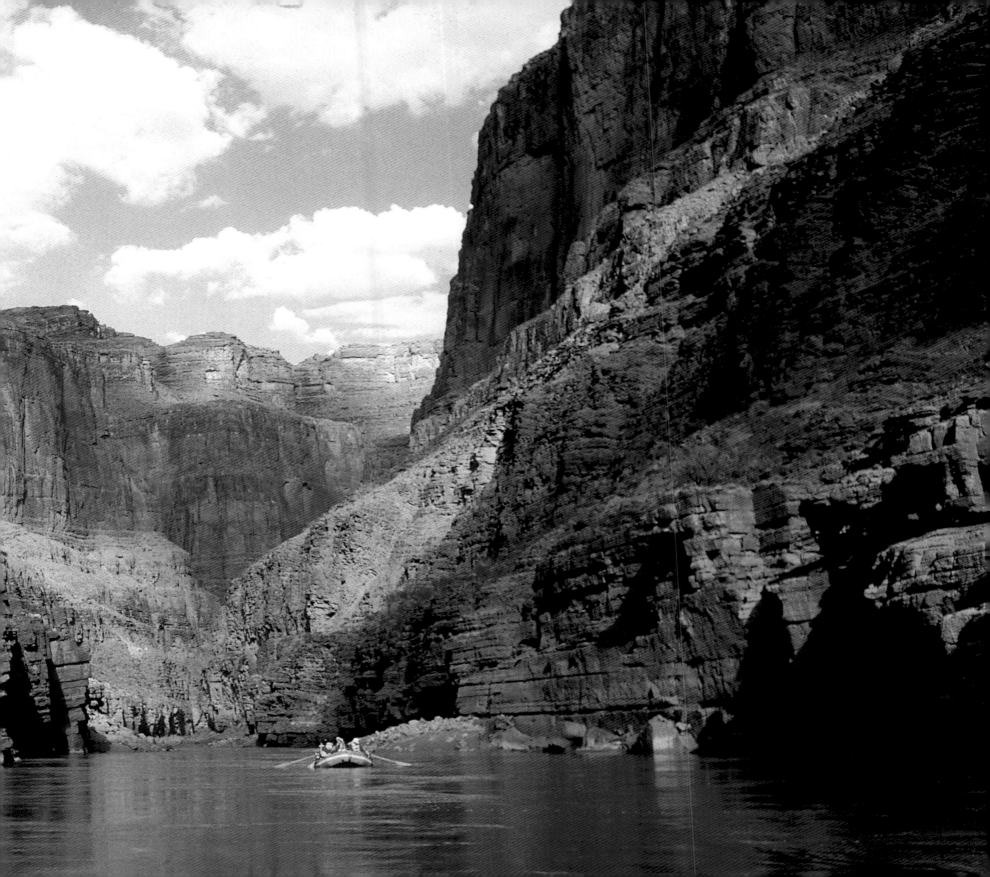

We traveled in Great Britain advising on public use of nature reserves, in Japan and Thailand filming national parks, in the Arctic observing the effect of snowmobiles on Eskimo life. We delved into archaeology and forest ecology, produced books and documentaries. Now Louis has died and I am in the canyon. Even when he told he had a fast-ballooning brain aneurysm, he wanted one more journey. This one. Down—Here.

I watch dawn light caress the canyon, voluptuously sliding and flaring over the walls, pairing fleeting moments with seeming eternity. I listen to sounds: The river's burble, gurgle, chop, splash, hiss, slap, and roar. Raven's chortle. Duct tape ripping. The tape holds my rain pants together and fastens a shoulder strap to my water bottle. It can, boatwoman Barb tells us, secure an injured person to a backboard if the Velcro gets full of sand.

When night comes, I lie watching the Big Dipper stretched nearly rim to rim across the darkened slot that cradles my sleeping bag, and I stare and stare at the Milky Way, ordinarily denied me by life in the city. The Milky Way has not been missing me, but here in the canyon I realize that I've been missing the Milky Way. Does estrangement require realization? Or is estrangement without realization even more insidious? To ride the river on a raft is to ponder.

Time clearly is an ingredient here, perhaps the main one. But how greatly canyon time contrasts with the span of a human life and with the busy-ness of our days. The canyon's clock is geological. Fine particles pressed together form the sandstone, shale, and limestone of these walls. Fine particles suspended in the river carve ever deeper. Fine particles stick to my notebook, bedding, lotion bottle, skin. And there's a universality in this. The world over, creeks, streams, rivers, and winds carry fine particles that wear our Earth's surface smooth yet also, when deposited, provide the material for new contours. Before Glen Canyon Dam wrought its change, the river swept five *tons of sus-*pended particles *per second* through the Grand Canyon. The water ran red, *colorado.*

Now sediments settle out behind the dam and the river flows green. Actually, today's impoundments are not the first for the Colorado. At least thirteen times in the last million years lava flows near the lower end of the canyon have dammed lakes. Water backed even beyond Lees Ferry, silencing the river, drowning the walls. Yet the canyon recovered—or rather reverted. We humans assume that beloved landscapes and biomes can be steady state, have a norm. But actually nature adapts to all

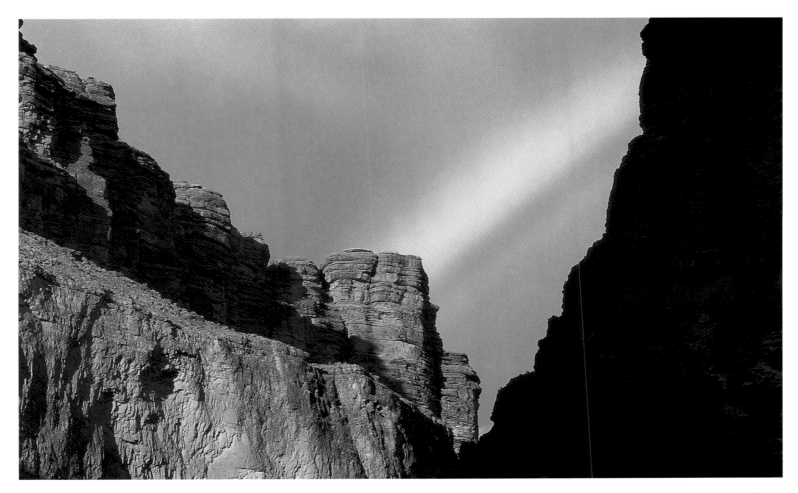

Rainbow from Tuckup Canyon

ON THE RIVER, AWE FEELS ALMOST MANAGEABLE;

THE WALLS DEFINE AND LIMIT WHAT THE SOUL

SEEKS TO COMPREHEND.

realities. It switches back and forth. Its balances are dynamic, its schedule open ended. This does not condone human desecration. We can pollute the air, despoil the water, denude the land. Nature won't care, but we will. It's *our* frail allotment of time that we wreck, not nature's.

Watch a rock plummet and bounce down just one of the layers here—the Redwall limestone—and you're looking at 40 million years of time. That rock dropped from the end of Mesozoic time, at the top of the layer, to the middle of Paleozoic time, at its base. Time made manifest in stone.

Or drift past hard, polished, black schist that is seamed with pink granite. The schist is Vishnu, named for the second god in the Hindu triad of Creation-Preservation-Destruction. It is 1.7 *billion years* old, formed when all life on Earth was unicellular. Vishnu schist is that old yet it has been part of the canyon for only a wink-of-the-eye 4 million years, the time the river and the side creeks have needed to reach this stage of their sculpting. Seas and swamps and desert dunes are now canyon. Is it raw materials that count, or processes? The cards we're dealt, or how we play them?

Impatience and transience permeate today's Western culture. The canyon offers antidote, and that—I think—is why its walls are so compelling. To float this great stone gash is to reconnect psychic landscape with physical landscape, and experience crescendo.

I-thou can only be spoken with the whole being.
I-it can never be spoken with the whole being.

MARTIN BUBER

60 RUTH KIRK

Faces in canyon walls

Every Time *I've pushed off and dipped my oars into the water at Lees Ferry, I have felt light, and then the rush of excitement for the adventure and the beauty ahead.*

Peace of Mind! *My favorite home, my sanctuary, my happy meter is beyond belief.* Laughter.

Community... *Watching the people transform. Seeing their happy meter go beyond belief.* Laughing.

Oh! *That very special relationship with running rapids or route-finding a new place. Yeah! To successfully make it ABC ("Alive Below Crystal"). To feel the same adrenaline rush before running the rapid, and then that wonderful lightheadedness after making it. To remain focused and have organized thoughts if I have flipped, had a bad run, or smashed my dory.* The Challenge.

Learning... *Something new every single day.*

Sharing... *The Grand Canyon is the best part, telling the stories, talking the geology, the history, and the botany with people who are seeing it for the first time. It* always *brings me full circle to my beginning.*

In Love: *Totally and forever to the magical, fairyland, timeless place called the Grand Canyon.*

OTE DALE
River Guide

Plant Journey

LINDA HOGAN

This canyon world

where water yearns

toward the ocean

is a place so large

I can't take it in.

Cardinal monkeyflower in Tapeats Creek

Instead, I am taken in, traveling a near dream as we journey by water, contained by rock walls. In order to see this shorn-away world, I narrow my vision to the small and nearly secret. Never mind the stone's illusion of permanence or the great strength of water. I look to the most fragile of things here, to the plant world of the canyon. The other river travelers seem taken in by stone, time, and water, and do not see the small things that tempt my attention, the minute fern between stones, the tiny black snails in a pond of water. I am drawn in by the growing life and not by the passing. It may be that I am simply a dreamer of the small and alive, or it may be that to see this world at our feet in the midst of the vast world above requires us a gaze shaped by another history than the ones recounted here by our river guides, a history that begins only with the journeys of white men.

This new history of the Colorado River, the one that began so recently, doesn't contain the vision of those who, for thousands of years, have known the land in all its sacred power and detail. This is a land so alive that the Havasupai address songs to it. And the Hopi people's place of origin is above the place where waters of the Little Colorado meet with larger waters, a place called Sipapu, opening, center. I know there is a wider way to see the canyon. I look for this wider way by looking down, at the plants. While I see plants as sacred, I am disturbed by the way in which they are unacknowledged by the others, treated with carelessness. It is hard for me to observe this, because I know that even something as small as a plant is not only alive and necessary, but that it can represent the known history and geography of a world.

Of all the plants we travel past, it is the short-lived blossom of the sacred datura that most strongly draws me in with its luminous white flower. Similar to a morning glory, even its trunk-stem glows with life, gold on deep green. I watch for these plants all along the way, and at each rest stop I walk about to find them, thinking of how their seed pods, which gave them the name "thornapple," have traveled along this water as we are traveling, how these plants have washed up and then staked a rooted claim in their place.

Perhaps its transience is what attracts me, because I, too, am only passing briefly through time and rock on the charge of water.

Or perhaps it is the datura's intimate beauty, shining with light and green intelligence.

Or that datura has the sweetest of smells when I sit beside it trying to learn its secrets.

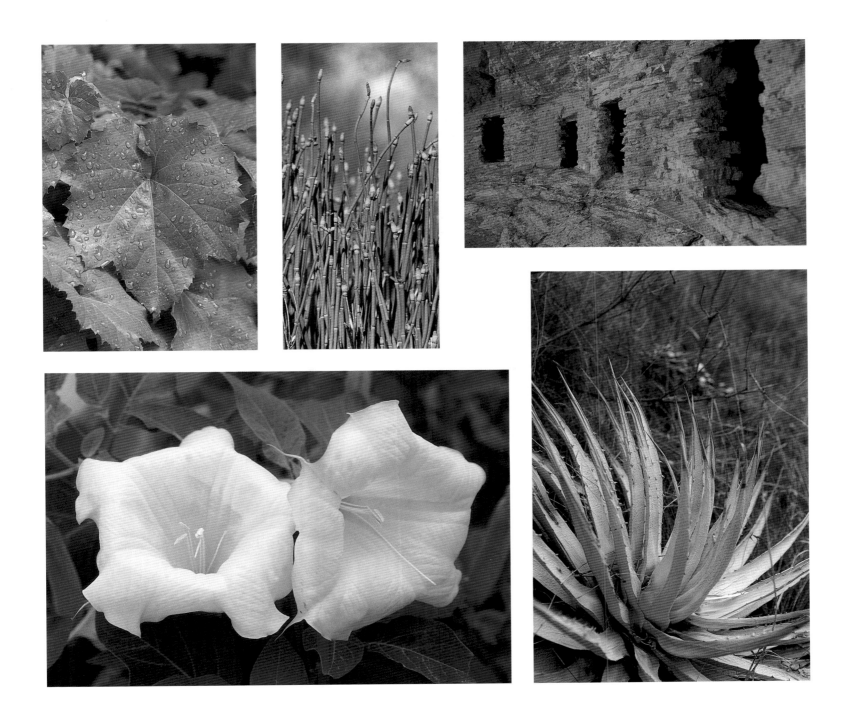

Clockwise from upper left: *Grape ivy, horsetail, Anasazi granaries at Nankoweap, agave, and sacred datura*

But most probably what takes me in is its history, one that traveled from ancient worlds and times into the present.

For whatever reasons, in the canyon I find that this plant has a language that speaks of what's too large and immense for a mere human mind to grasp. You could say it holds the secrets of the world around it. It tells its story. Part of the story is in its relationships with other life forms. It opens its white evening flower, as if it is made of light, and the night-flying moths arrive, drawn to its sweetness. I see them enter the flower that is delicate as dusk, overpowering in its softness. By day, other pollinators arrive, insects, birds, some intoxicated by the plant's narcotic quality.

This plant is also kin to water. It has traveled many world rivers, not only the Colorado, on a mission unknown to us. Its use has been recorded in India, South America, Russia, and China. The Aztecs painted its likeness on murals. The priests of Apollo used it to treat such illnesses as epilepsy. Datura shines with a power as immense as the passage of water across the world, the movement of it as mysterious as the force that carries water upward through stem and leaf, as powerful as that which carries a river to the sea.

Like all plants, it has its relationship, as well, with light. But most significant is its long, ongoing relationship with humans. Every plant has been an offering to the human world and this relationship is what I wish to understand.

For the first peoples the plant world has always been an offering to humans, of richness, healing, and food. And to those who can read and understand the plants, knowledge resides in the body of the plant itself. For tribal peoples a plant is a living being, considered to be a person, as worthy of existence and survival as a human. To our ancestors, plant knowledge was both medical knowledge and a part of sacred history. In a relationship developed over many thousands of years, plants and people were allies in healing. This has not been the case in the more recent Western model of the world. Most humans in this time haven't been fortunate enough to learn the gifts of plants, have forgotten to regard the plants with their full measure of respect. These days, plants are likely to be overlooked, unseen, and unremembered in their subtle vitality. For this reason, I offer the plants my attention and affection. I know the subtle has power every bit as strong as the water we travel and the years of time shaped into canyon by this downward-rushing Colorado River. In the same way that the river never

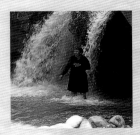

The Colorado River and her canyons are home, the quintessential home, country matched to my own patterns; intricately branched veins twisting through an angular body; a restless spirit and stable, stratiform soul. I never go for long without checking in on some tributary, sinking into canyon stillness, finding the rhythms of flowing water. The Grand Canyon is where I am smallest, awestruck, delighted, and liberated by my insignificance.

ANN WEILER WALKA
Naturalist/Poet/Backcounty Guide

At play in Shinumo Creek

leaves anything unsaid, the plant expresses itself with every atom of its making.

Datura has been of great value as a medicine and as a spiritual ally for tribes on this continent. I love and admire this plant. I know that the story of this plant, how it was once worshipped and came to be considered a toxic weed, is the same as the story of the canyon itself, one of how the sacred loses its power. It is also the story of water, valuable only in its use to us.

This white-flowered medicine in use since nearly the beginning of all civilizations is now considered a poisonous weed, "rank and noxious" and hard to destroy. It is true that people have died from misusing it, even recently, but for those who know its ways, it is alive in its potence, and sacred. It is clear from the plant's history that it is a beautiful power, a flower of the dream, one used as a passageway to other dreams and places, the supernatural and the sacred. The plant that travels the water is esteemed for its offering of vision, of the spiritual journey to other worlds. In this, it is part of the same story of the luminous canyon that puts travelers in touch with the great beauty of a sacred world. The world is not here just to be visited by humans. It has its own repose and turbulence, its own journey and destination. The sacred datura itself is one of many travelers. The whole world is a river through which its seed has journeyed. Unlike the Hopis who begin here, no one knows from where datura came. I say it came from here, this dream, this water and light.

But then, this is the land the tribal people sing to, with emotions deeply felt and love unsurpassed.

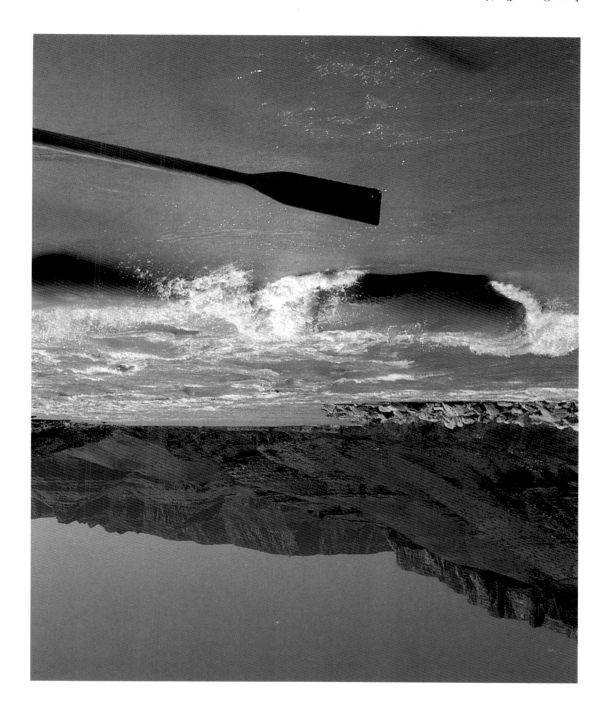

Paddling Right

LEILA PHILIP

Rafting on the Colorado River through the upper half of the Grand Canyon was one of the hardest things I have ever done. To make the journey I left behind my six-month-old son.

The invitation to raft the Grand Canyon had come when I was still pregnant, and at that point the decision seemed relatively easy. Who could turn down a chance to raft the Colorado River through the magnificent Grand Canyon, symbol of the American West? But that was before I had held my baby Rhys, a warm bundle in my arms, and felt the world spin to a stop. I had fallen under the spell of his sparkling blue eyes and irresistible Mr. Joyful grin.

When we enter the river at Lees Ferry, the sun is already a searing blade. I peer out through my sunglasses and put my hand into the clear river, feeling the sting of cold. Our river guide estimates it to be 45 degrees. "If the boat flips in a rapid, swim," she lectures. "You don't have time to wait to be rescued. Get yourself out of the water." Her warning fills me with excitement and fear. I know something of whitewater. In high school I competed in whitewater kayak races, but when I was seventeen had almost drowned in a kayaking mishap. I had not been on a river since.

Now I am on the Colorado River about to ride a raft through big water and I am a new mother. When I left New York the morning before, I had woken as usual to nurse Rhys at 4:00 A.M., but then could hardly bear to put him back in his crib. I kept

staring at him curled in my arms, a grin on his sleeping face, a dribble of milk on his chin, then I was weeping at the thought of leaving him for a week.

Soon we head into our first rapid. "Tighten your lifejacket straps," our guide tells us. Our raft dives into the whitewater, then bucks up and down through a series of waves. Water smashes over the raft, rolling us like dice. Which way is forward? I can't see through my dripping sunglasses, but I don't care either. We are riding on raw power and are coming through. The thrill makes everyone, even our guide, whoop and shout.

Then as quickly as we have entered the rapid, we are out. I wipe my soaked face and see that, like me, fellow passengers are gripping the sides of the raft like children, their faces radiant. I think of Rhys, of how he clings to my arms, his face beaming, a tiny explorer as I carry him through the house. Here on the river, thousands of miles away, I feel suddenly close to him, as if I now share something of the state of awe which is his every waking moment. I am no longer a new mother, struggling to nurture her career as well as her baby, trying to do six things at once while the baby naps. My mind is no longer an overstacked tray of dishes—chores, writing projects, phone calls—all delicately balanced and about to tumble.

Each day I am pulled closer to the water. In calm stretches, when the sur-face of the river shimmers gossamer, I dip my paddle through the smooth surface and fight a momentary impulse to jump in. Riding the rapids, I am addicted to the feel of the river's power against my paddle, to the crash of cold water that smashes over us. And when we are through, the danger over, I sink my fingers into the boils of eddy water. At night, curled in my sleeping bag on the sand, I still feel the current's rock. When I wake, the moon rests on the canyon's rim, a slim white boat floating in blue sky.

On the fourth day, I ask the trip leader if I can try the inflatable kayak and paddle solo on the river that day. The sky is gray and the water glass. I will have to manage several riffles, but only one major rapid named President Harding, which our guide says can be called "President Hardly" if one enters the rapid correctly. In the kayak I remove my helmet and lie back against the center cushion, closing my eyes. Left to the current's whim, the kayak spins slowly around and around. The river is so quiet I can hear the rustle of bushes on the shore. I keep my eyes shut, feeling the river's glide. This is the

Passenger Katie Bates paddles an inflatable kayak called a "ducky."

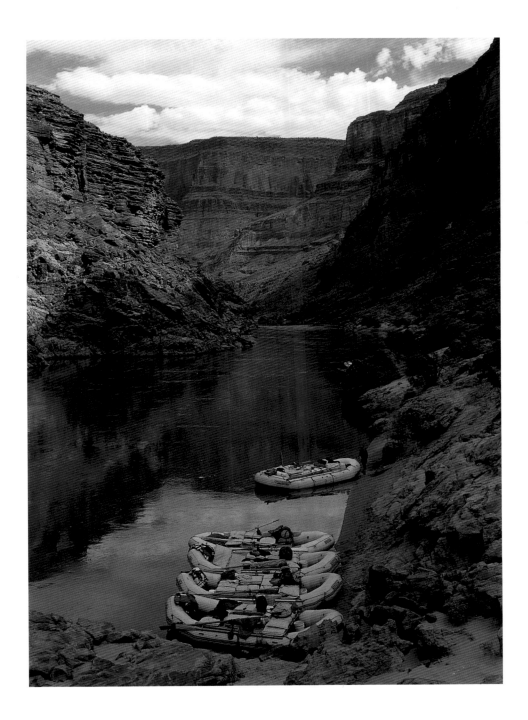

Rafts await passengers hiking at Elves Chasm

I came to the Grand Canyon—the great (w)hole—for a reason: to listen and watch and wait. And now, so many years later, chewed by the River's rapids, swallowed whole by the Canyon's gaping maw, I am spit out—transformed—the place of emergence.

GREER CHESHER
*Resource Management Specialist,
Grand Canyon National Park Science Center*

Snowy egrets

sound of time, moving us forward imperceptibly. When I open my eyes, the red walls of the canyon have closed and now shoulder the river. I see the guides strapping down gear in preparation for whitewater, and I put my helmet back on, then reach for my paddle. The rapid begins as a whisper, faint at first then louder. The water picks up speed. I feel a rush of adrenaline. The last time I was in a kayak I was riding upside down in frigid water, strapped into my spray skirt until I finally got myself free. *What am I doing here?* I suddenly think. *I'm a new mother. What if something happens to me? What about Rhys?* Yet it feels good to be alone in the kayak on the river. I feel something of my old reckless, adventuring self. Ever since Rhys was born I have begun to see the world as a series of potential hazards—a bottle cap as something he can choke on; the bed a terrible height from which he can fall; even the spoons he loves to grab pointed objects he may poke into his eyes. To be a mother, guardian of new life, is to become implicitly conservative.

I practice turning into eddies, digging my paddle in hard, then paddle forward and backward a few times. "Stay to the right, the far right," calls the guide on the oar boat I am to follow through the rapid. "There's a big boulder under the water there, so don't go over that. But don't get pulled left either. Work at paddling right. The water's big today." I steer the yellow kayak down and into the tongue of the rapid, paddling hard to keep to the right. But as soon as I feel the force of the current I know that I am no match for the river which sweeps my small boat forward in a terrific rush. Before I know it, twin walls of water are rising up around me. The kayak is sucked forward and up then down into a cauldron of boiling whitewater. I feel the boat buckle then flip like a potato chip and I am thrown out into the river and am tumbling. The river tosses and pulls me this way and that. I am sucked down into absolute coldness, then pushed up to the surface. I gasp and sputter and cling to my paddle while jerking my arms and legs in a semblance of swimming. The river pulls me along at what seems like a fantastic rate. I don't see

any boats, and the shoreline is spinning by. *Swim*, I tell myself. *Don't panic. Swim.* I can see an eddy to the left and thrash toward it. Suddenly the yellow tube of a raft bobs near my face and hands reach down to grab the neck of my lifejacket. I hear people shouting, "One, two, three, pull." I am lifted out of the water and land in a heap in the bottom of the raft. Faces are peering down at me.

"I still have my paddle," I say weakly. I am so grateful to be out of the river, I smile. "She's smiling!" our guide yells to the other boats, who had watched me flip in the rapid and now wait anxiously downstream. "I want my boat back," I say, and I do. I wasn't ready to get spilled into the river and I am both astonished and enraged. Our guide throws me polypropylene underwear, rain gear, and a wool hat. I gratefully pull the warm clothing on over my wet skin.

Back in the kayak I paddle hard to get warm, weaving back and forth across the river which is once again serene, the silver water one smooth sound. I am freezing but feeling great. I've been baptized by the river, and reborn as my pre-motherhood self.

One week later I am back in New York, holding Rhys while he nurses intently, but I have only to shut my eyes to be once again in the canyon. I can see the red rock, lit with sun as if on fire from within. I can see the stars, so many it seems as if the night sky is draped in lace. I can smell the gentle tang of tamarisk, and I can hear the water, rushing like time through the canyon.

Riversound

ANN HAYMOND ZWINGER

On this August morning, I note the river runs unusually high. As the raft

swings out into the current, a breeze lifts cool clay fragrances off the water, and through the water

I watch bright green algae stream like Nereids' hair. On river left, the familiar

vanilla-taffy Kaibab Formation rises out of the river, eon stacked upon eon.

The resident Lees Ferry great blue heron beats downstream. At the first riffle, a fathomless sense of

well-being washes over me: home again, home again.

Mule deer buck in velvet

Since I am the only member of her group of writers who has been on the river more than once before, Kathleen Ryan launched me with two questions: How many trips have I done, and why do I keep coming back?

As for the first question, in the years of writing a book about the Colorado River in Grand Canyon, I traveled time available—a week here, a run-out there, a hike down to meet a group—difficult to calculate. More to the point, a single trip is like a first date: enthralling, but does not a relationship make; one needs time, patience, many trips to learn where the rocks and eddies are, the true temper of the river.

The second question haunts me. Certainly a powerful reason I return every chance I get is that the Grand Canyon presents a grand, dazzling panoply that cannot help but sustain me. But there must be more, and I ponder that question while I walk up North Canyon and watch whiptail lizards dart across the path. Rosy-rust sandstone slabs, cut with crisp curving lines of exfoliation, wall the canyon. Water fills temporary pools on which water striders skitter. Huge buds, ready to open white trumpet-flowers this evening, caparison a big datura bush. A yellow swallowtail wafts through a shaft of golden sunlight. At the end of the canyon, a silver wire of water slithers down a high, curving back wall and fills a small basin. Yes. This is one reason I come back: to cherish the grace of the familiar.

Because I prefer rowing trips, I never thought I'd enjoy a motor trip, but Clair Quist, with whom I went on my first river trip twenty-five years ago, is running a new, quieter, almost acceptable four-stroke engine. But being on a motor trip compacts time. Rowing presents all my familiar landmarks in a slow, measured sequence. A motor trip speeds things up, the tempo shifted from minuet to fox-trot. Still, with human hubris, I relish knowing what's ahead because I've been here before.

Rain drenches us the next morning. Water feathers off cliff rims, bright hematite red, wisps that coalesce into frayed ribbons. When we arrive at Nankoweap, I am soaked to the skin. The clean witch-hazel scent of flowering seepwillow floats through the damp air. Rain pelts the tent most of the evening. Wagnerian cracks of lightning and kettle-drum thunder accompany the borborygmus of distant rockfalls. Suddenly a fall reaches the river with a bass-drum KER-BOOM!!! that ricochets off the walls: the clamor of change.

At Phantom Canyon, we learn that a flash flood required the evacuation of Havasu Village. As we continue downstream, we see where marauding water recently ravaged

Some stand on the edge of her and tremble. Some feel she will pull them to an endless fall. All of my life I have been with her, and I share none of that fear. For me, the Canyon has been a place for living, hiding, and healing. She always draws me back.

I have the incredible luxury of putting my foot in a stirrup and filling my eyes and my soul with her while my long-eared partner watches every step we take. How is it that fortune has smiled on me so abundantly? I am truly blessed.

PATTY KNOX
Trail Guide

Prickly pear

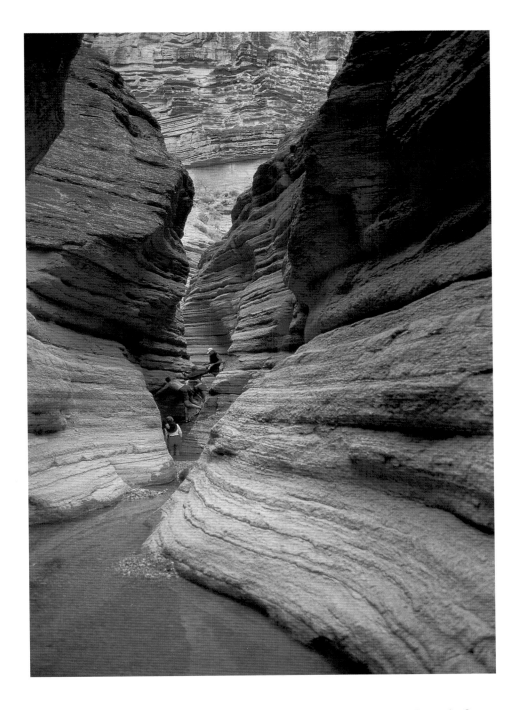

Hike up Matkatamiba Canyon

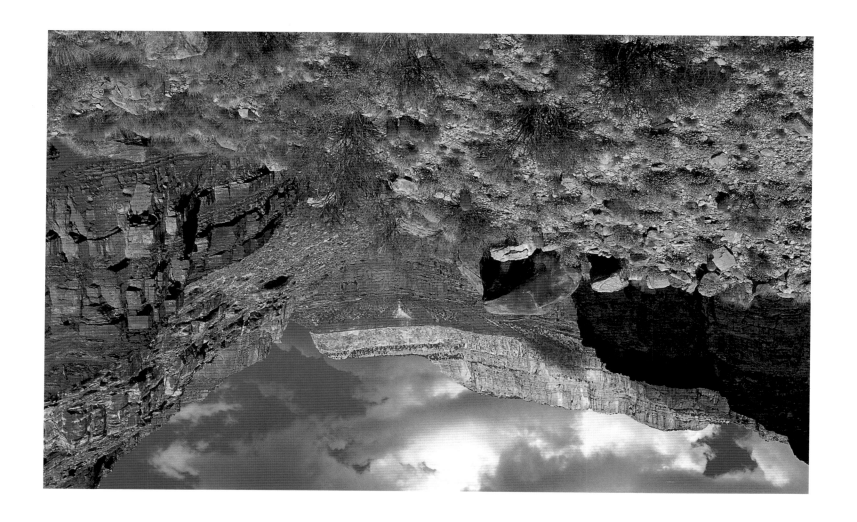

sandy beaches, baring their cobble underpinnings. Downstream, I savor Blacktail Canyon for its gorgeous acoustics when tree frogs and red-spotted toads are mating, and because I can put one hand on either side of missing millions of years in the Great Unconformity. This morning it has more pools than usual, some hip deep. But no tadpoles flutter in them, suggesting the torrential rains flushed them out.

Stone Creek runs brimful. The waterfall, usually a lacy curtain, thuds uncomfortably on my shoulders. As I stand beneath it, I squint upward to watch water spray off the rim, the drops like fire opals lit by the sun. Another reason I come back: to be baptized by the canyon's brilliant, iridescent water.

At Matkatamiba, always a serendipitous interweaving of sunlit walls and shady shelves, the change astonishes me, a recognition I could not have if I had not known this place before. On the wall the flood line wavers ten feet above my head. Clair reminds me that a refrigerator-sized rock that sat here is gone: Too big to get down the narrow-walled stream, was it simply battered to bits and sluiced into the river? Where once grew a garden of false hellebore orchids and cardinal flowers is now bare mud. Shocking, the vandalism of water.

To re-establish contact with the place I knew, I close my eyes, cup my ears, and listen to reverberations I do not otherwise hear. Added to the familiar prattling of flowing water, my ears pick up a delightful, delicious pizzicato pittering and the breathing of passing air. I hear flutings of stone, kyrie eleisons of canyon wrens, sonatas of sky, all the old refrains of the quintessential and the eternal.

Back on the river, currents writhe and race like snakes, curling into vortices, siphoning into firehose-sized holes that spin counterclockwise down into eternity. As we transit the last rapid, caramel-colored waves froth back on themselves, booming and smacking. Then quiet river. I feel let down, as if the trip is over before it's over.

The speedboat picks us up at seven the next morning for an ugly, noisy exit. We burr through massive cliffs of unremitting grandeur, walls with towers and pinnacles like monumental stage flats waiting for the opera to be mounted.

As we round a bend, sunlight hits me full in the face, a sudden blinding illumination: Once I discovered river water coursing through my arteries, I needed to have constant transfusions. Here I'm expected to lug my own duffel, pitch my own tent. Nobody takes me by the elbow to cross the beach. *That's* why I come back: to stay alive and healthy, vital and exuberant.

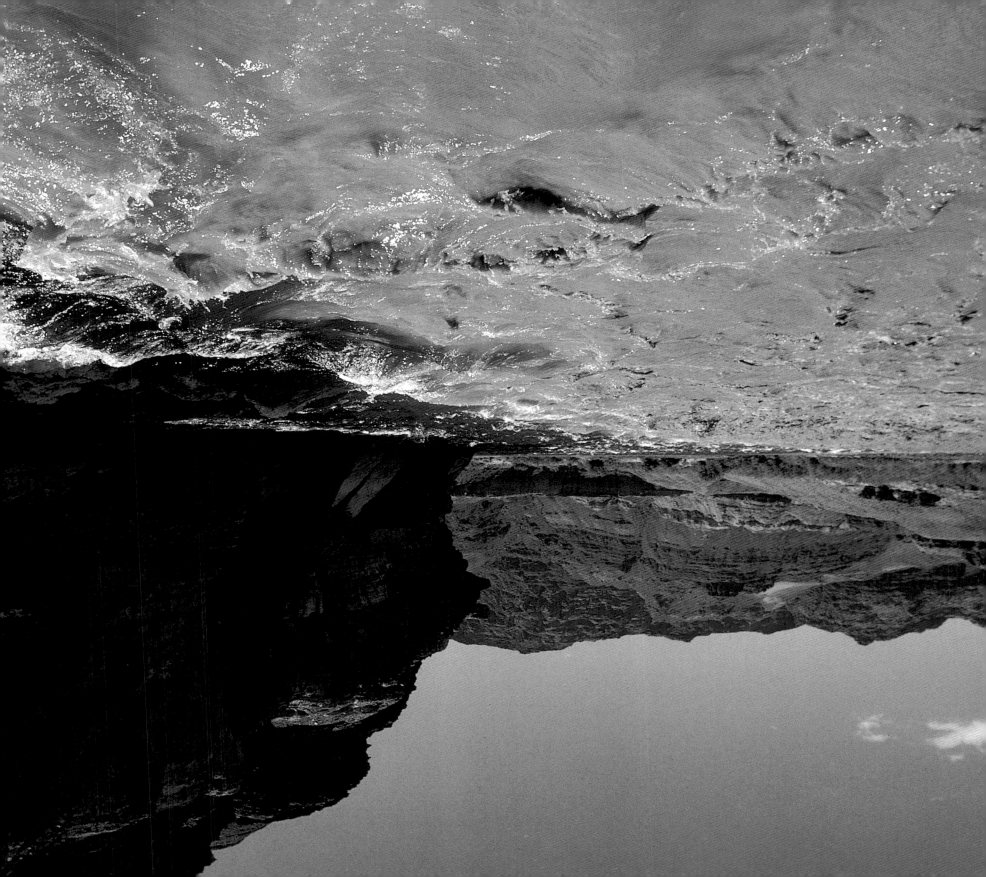

Falling into the Canyon

A N N I C K S M I T H

*It is the end
of September, and for
the second time
in my sixty-one years,
I am falling into
the Grand Canyon.*

Left: *Paria Riffle, confluence of Paria River with Colorado River* Above: *Deer Creek*

The first voyage was in May of '94—friends and lovers platooned on a large black motorized raft. The Colorado carried us down through amber, sienna, rose-colored layers of rock—a descent vivid and unreal as dream. We fell into time and found bedrock, the schist called Vishnu glowing silver-black, sculpted by water, older than life, two billion years old. I remember the trill of canyon wrens. A distant roar of rapids.

This morning, as the Canyon Explorations bus winds into the earth-crack called Marble Canyon, I feel like crying out, "Hey, dream, here I come again." Alone. No love for anchor. Flame-striped mesas tower over me, and at my feet is the chasm. We are dropping through Earth's crust toward a path which will be water.

To my delight, I discover that three of our guides are women: Nicole, a green-eyed Italian whose icon is mermaid; and Laura, who reads Mary Oliver's poems to us and looks like a model; and blonde Meagan, the daredevil who runs up mountains. Larry, a veteran of the Colorado, will be our leader, and a wry artist named Sam will be the oarsman riding sweep.

Pulled up on the landing at Lees Ferry are four yellow oar-powered rafts loaded with gear, and a sixteen-foot paddle-raft. This is the last day motorized boats can put in, so there will be no gas fumes, no stutter of engines to break the illusion of wildness. We smear sunblock on our noses, adjust our not-quite-broken-in river sandals. It's a motley group. Not the well-heeled rich but working couples, brothers, families who saved sweaty cash to be here. Oddly, women are the driving force. What is it we women desire?

I, for one, desire always the physical. Stone, leaf, rain, blood. I want to see clearly the red-spotted toad, the blue beetle, the purple petals of a four-o'clock opening to sun. I want to scale cliffs, touch Anasazi shards. I want to wallow in the desert's heart. It pleases me that no one, man or woman, mentions the adrenaline rush of running rapids, the need to prove oneself in contest with the river.

Our first day in Marble Canyon I drop swiftly into rivertime. Hours are marked by the angle of sun, shadows on riffles, the growl of a stomach. The river cuts through strata of limestone, shale, and butter-gold sandstone, and we are insignificant as the common white butterfly—a flutter of wings against ancient faces.

The Colorado, blue-green at Lees Ferry, takes on the tone and texture of chocolate milk as silt-laden tributaries dump their loads into it. Even the turquoise waters of the Little Colorado, which emerge from sacred Hopi birth springs, are running brown. It has been raining monsoons for weeks, and the canyon's slopes, ridges, gullies, and beaches are splashed with an improbable electric green.

The river bends and I spot a blue heron etched on a cliff like an Egyptian hieroglyph. Another day, snowy white egrets take wing over redrock. On warm stones, a collared lizard with yellow feet pumps up on his hind legs like a mechanical toy. So much amazing life. In camp, the night-blooming sacred datura unfurls its fragrant, hallucinogenic, toxic white petals, beckoning the sphinx moth to feed and humans to dare the most dangerous sexual dreams.

At Pipe Creek, I join the paddleboat crew. I'm a veteran, having paddled two days despite a bum shoulder. I love the team effort, the action and focus, the breathless rush of riding square in the maw of the river. Our raft is strong, light, unencumbered by gear. It ventures into waters no oar boat would dare. Three rapids rated 8 to 10 on a scale of 10 await us.

Meagan is at the helm. Paddling on either side are Della and her strong grown sons, a nurse, an optometrist, and me. We scream through Hance and Granite Rapids, stroking down glassy V-shaped tongues, skirting the holes, pulling through waves that rise above our heads. Meagan maneuvers us into the calm at the tail of each rapid and, released from danger, we let out a wolf howl of victory. She stands in the stern, eyes wild blue, hips swinging in her paddle dance. Living the moment like children, we raise our paddles above our heads, slam them on the water.

Meagan, at twenty-four, has run the river seventy times and never capsized. Now clouds darken the sky and the day turns cool. The rangers at Phantom Ranch had warned Larry a hurricane was approaching. Several people have been swept from side canyons by flash floods to drown in the river. A headwind blows in from the west. Only one rapid to go. Hermit, the roller-coaster ride Sam told me is the most fun of all.

The Canyon is life to me.

It's the full moons. The moon shadows on the Canyon walls. Looking up at the stars as I lay in bed. Venus reflecting on the river.

It's the faces of the people when they float the Little Colorado, see the beauty of Havasu Creek for the first time. Helping people hike to beautiful places where they normally wouldn't go.

It's letters from these people, telling me how their lives have changed forever. These little glimpses are reminders of why I can't leave.

It's looking at my coworkers and giving each other the thumbs up above major rapids.

It's the Canyon walls, rainstorms, Thunder River, Deer Creek, Hermit Rapid, Whispering Springs, and the sense of accomplishment after every trip.

I don't have a choice about whether to come back to the Canyon. I have to.

KIM CLAYPOOL
River Guide

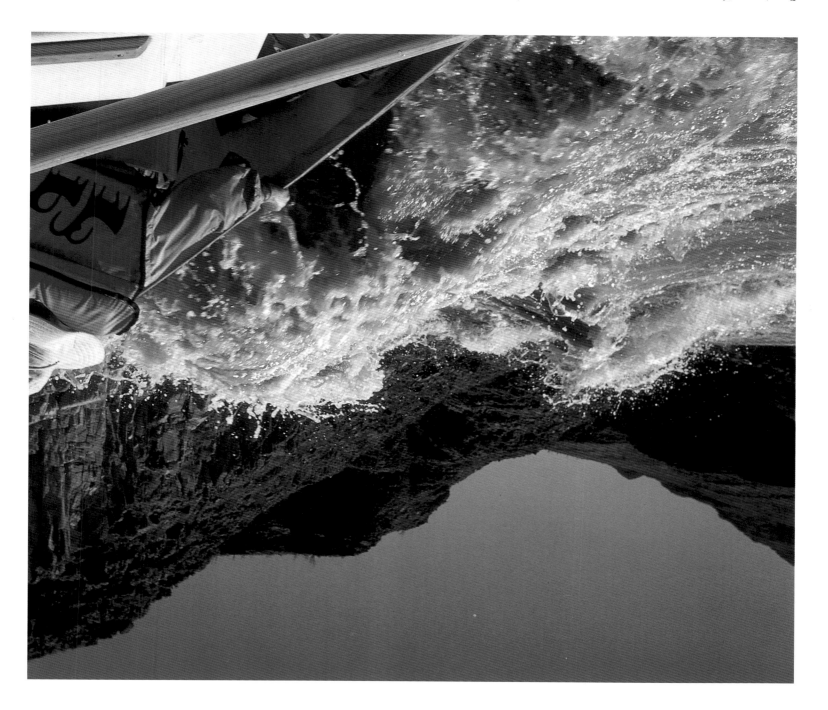

First, as always, is the roar. "Forward," shouts Meagan. We drop from calm into havoc, attacking Hermit's wave-train head on. One, two, three, four giant waves lift us. All I can see is the high brown foam, the dense fury into which I must place my paddle as we rise and fall. Breakers slam into us, slap our faces, drench us in icy blasts, but we keep stroking to a beat set by the lead paddler—stroke, stroke, stroke—for a paddle wedged in water will keep you saddled on the slick yellow sides, and momentum carries us through even this fierce water.

Then comes the fifth wave. We climb up and up, stroking hard, but we do not cut through. The wave grows. It's a demon curling above us. Its foaming dragon breath is distinct as a Japanese painting, alive. Now I am stroking air. The raft is hanging vertical in air. Then the crest breaks. We are thrown back. The boat flips. We are flying.

I go down a long way. Buried in the brown deep, I'm a pebble in a maelstrom. This is power pure, power strong enough to drive turbines. I am holding my paddle. I let it go. I push up through the icy turbulence until breath leaves me and I am choking, swallowing water. A gulp of air, blessed air, then I am driven down in a whirlpool. Up and down and up again. The river roars past rock walls and I'm still helpless.

> *The wave grows. It's a demon curling above us. Its foaming dragon breath is distinct as a Japanese painting, alive.*

Inert as driftwood, I bob toward an eddy, held afloat by my life vest, dazed, numb, gulping air. And I'm drifting away from the rescuing oar boats. I swim toward Nicole's raft, kicking despite exhaustion. A man's hefty arm grabs mine. "Annick," says Nicole, "you're bleeding." She leans close, her long brown hair in my face. "Who am I? Do you know what's happening?"

"I'm okay."

She grabs my vest and yanks. It isn't tight enough. It slips above my eyes. "Can you give me some help?"

I want to help, but I'm a stone. When they pull me in, I lie on the boat's self-bailing bottom, gasping like a landed fish.

The night is windy and cool, with no stars. My head throbs from a welt across my forehead, a cut below my right eyebrow, a bruise across the bridge of my nose. All the rest

who had "gone swimming," are equally shaken, but not injured. It seems a paddle hit me as I went overboard. Maybe my own. Probably the handle of the paddle in front of me.

Forsaking a mirror, I smear my wounds with oil of arnica, take two aspirin, drink a gin and tonic with the crew. I down a beer at dinner, swig brandy from my stash, pull on long underwear, and still I'm shivery. I put up my tent for the first time, glad for cover.

"Tonight," says Larry, "you may wake up crying. It's a thing that happens. Come over and I'll comfort you."

"I don't think so," I say. If I need comfort, I'll go to the river women—Nicole, Laura, or Meagan, who is also wounded, nursing her pride.

Deep in the night I have a nightmare vision. An amorphous brown glob like a giant amoeba advances toward my tent. It flows closer, relentless, unstoppable. I know it is coming. I wait. Its weight creeps over my head, my chest, crushing breath. I lie passive as the brown glob engulfs my legs, my feet. The terror seems endless, and then it's gone. I watch it creep away. I am awake, tingling with fear. I know it won't come back. I'm safe.

I ride fearsome Lava Falls in Nicole's boat, face forward into the waves to keep the prow down. She skirts the ledge, glides skillfully through the thirty-foot drop. The paddleboat follows. Every craft passes the test and we let out a great cheer. On the thirteenth day I'm ready to mount the steed again, paddling front-right, setting the pace through the final 7+ rapid. It's taken four days to gather courage, but the ride is perfect and I am redeemed if not reborn.

Our last camp is on a hot beach at mile 220. We use the paddle-raft as a water slide, leaping and splashing into cold waters. The river has allowed us to pass in ecstasy and fear—men and women together as a team—and now we can laugh. At dawn, we will float the six final miles in silence.

After dinner, in the warm dark, people talk about what this journey has meant. "It's made me stronger and more humble," I say. "More surefooted, but less sure in my head. I've learned a few things about mortality."

I am referring to Hermit Rapids, but also to a sunstruck hike up 1,800 feet to Thunder River. Falls thundered from limestone caverns to a leafy oasis, hanging gardens of maidenhair fern and cardinal monkeyflower, clear blue pools—the source. And to the

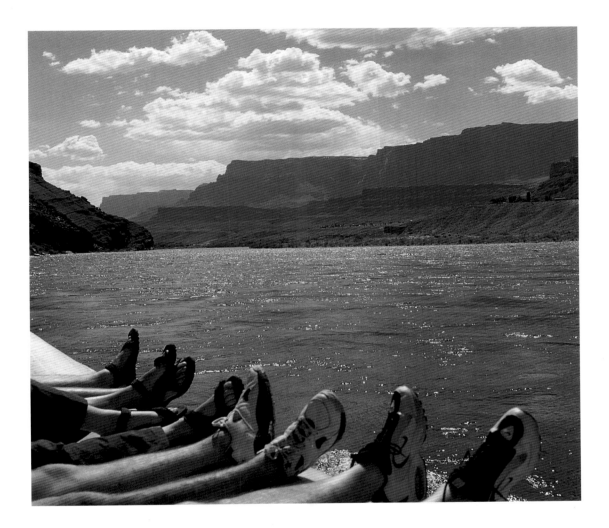

bighorn ram who stood looking out at the canyon this dusk from the top of a high lava outcrop called the Gorilla's Head. The last glow of sun lit his horns, which swept forward in heavy curls, like waves.

The ram stands at the apex of his world. He is my living shrine, transient and magnificent as the canyon wren, the Bright Angel shale, the fire ants, and us. He tells me this path down the river is not a fall into dream but into the great reality—the only one and only.

Leaving Lees Ferry

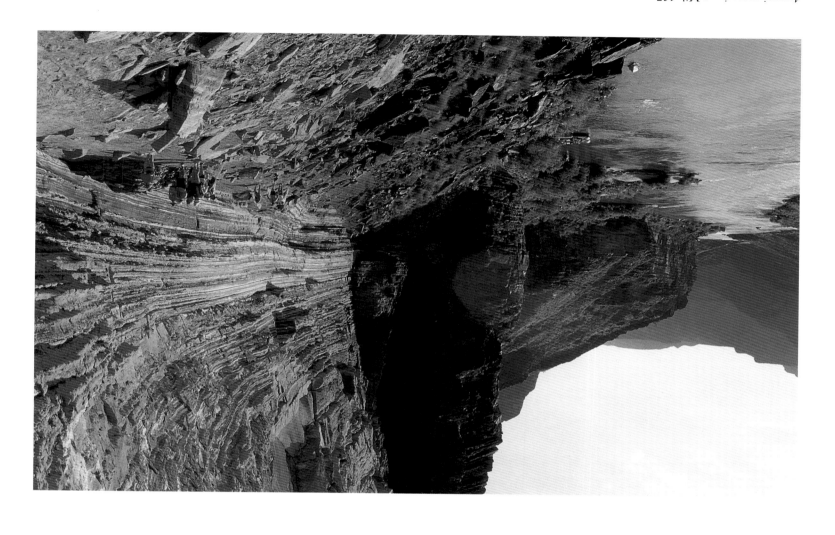

Making Peace

BARBARA EARL THOMAS

I have river sand in my pockets and pink canyon light beneath my eyelids. I can recall at will the milky consistency of the waves rocking the huge pontoons of our raft—feel the power of the water pushing in constant birth to move the river along.

My first night in the canyon, meteor showers rain down, keeping me awake all night. I can't close my eyes. It's too dull inside my head when the sky is raining stars. My tent is up but I sleep outside anyway. In all my years I can't remember sleeping out much. Even though my family spent countless days fishing Northwest lakes, we'd pass the night in old wooden cabins or in our car.

At 2:00 A.M., the wind kicks up, blowing its hot dragon's breath and sand through the canyon. Rock walls contract and expand, wheezing the sound of a million crickets' ceaseless buzzing. My former life seems nearly unimaginable but I can't quite shake the feeling that I'm not supposed to be here. Sheer cliffs, canyon walls, whitewater rafting—my mother would not be happy about this. This is especially true given that nine years ago she and my father lost their lives when their small boat capsized during a routine outing. I've been terrified for months since agreeing to do this trip. It's not just my parents' accident or the trip itself that has me going. Rather it's that and all the stuff I've gone through to get here. Like the airplanes—I don't like them, especially the real small ones. I am claustrophobic, due in part, I think, to a cousin who once stuffed me into a dufflebag and locked the top and left me for awhile. The idea of crawling into a handbag-sized plane gives me the willies. Then there is the hiking featured prominently in the brochure. I don't hike. I like to walk, but not straight up. I lack affinity for high places, which is another reason that I don't like to fly. And the bathroom, where will it be? God knows, if there is a category in the world for "girls least likely to go down the river on a raft," I am in it.

I've never been in a boat on a river. I'm from a family of black Southerners who I would describe as still-water people. Where I come from you sit still and fish. Going fast in a boat for any reason is just not done. My mother would think this a daredevil scheme, and so would most of my relatives, so I avoid telling them. It sounds so ridiculous that I hesitate to say it out loud, but I don't think this is something a black person is supposed to be doing. Even the old bus driver, the only other black person I've seen anywhere near here, drops his jaw when he sees that I am part of the group. Soon as I

see him I know that he is going to say something to me, so I wait until the last minute to throw my knapsack into the back of the Canyon airport bus, hoping I can slip past him. I have no such luck. Without missing a beat he stops arranging the bags and looks straight at me. With his head cocked to one side, he says with eyebrows arched in disbelief, "You goin' down the river?" Here I am caught in the act. I put my head right down on his shoulder and, in desperate confession, I say, "I know I'm not supposed to be doing this." Puzzled, shaking his head, he shuts the doors. "Goin' down the river? Umph. Well that's somethin' that ain't never crossed my mind."

Is this an omen—a last chance to bolt and save myself? I think of my mother and father. Life is cruel, but if I am tempting fate it's not death I fear so much as life's irony. I could not bear the thought of my family having a shoe drop in the same pond twice. If my mother were alive she'd say, "Have you lost your mind? Don't you know life is short and hard enough without adding crazy stuff to it? And besides, it's only fools and people with too much money who'd pay somebody to scare them to death if they don't drown them first." I am left on my own to make peace with fear, and to sort out for myself the difference between taking a chance and using good sense.

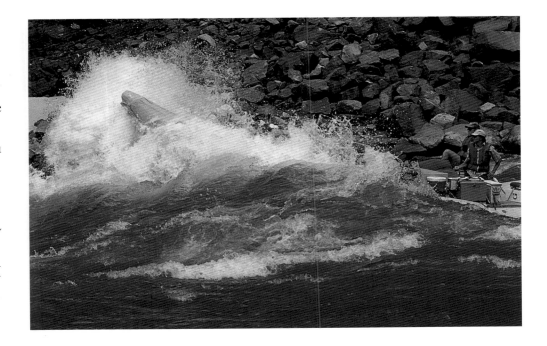

My eyes open at sunrise to a flurry of black butterflies. Moving silently in undecipherable patterns just above my head they circle, float, and then disappear into the canyon light. Simultaneously I catch the sounds and smells of our camp waking. Counting our river guides, we number more than thirty—a group of young and old, randomly thrown together to form an impromptu family. The canyon defines our universe. We are the only people in the world.

Motor raft through Hermit Rapid

Light is the subject of the canyon's morning drama and it recasts each moment. A sun flash startles, momentarily backlighting the canyon walls, flattening them into one massive silhouetted cutout. I want to kneel, pray, and scream all at the same time. My sense of life is too small, my human circuits too weak to contain the scale of this beauty. It rushes in and breaks me down. Suddenly, I'm inside of Bernini's *Ecstasy of Saint Teresa* when the golden rods of divine light pierce her marble body, rendering her limp. A person could die from too much of this.

Scrambling to keep up, I quickly sort out what I need for a day on the river. Shaking shoes and opening bags away from my body, I want to avoid seeing what might be sleeping inside. At breakfast I tell everyone, "I saw meteor showers last night and this morning there were black butterflies like you wouldn't believe!" Tom, our river guide, says, "No, actually what you saw were tiny bats, not butterflies, come to eat insects that would otherwise be eating all of us." When I protest he says, "Plenty more to worry about out here besides bats. Anyway they're gentle creatures—fly by radar, haven't ever heard of 'em crashin' into anybody unless they were ill." My brain can't translate butterflies into bats so I decide to pray for their perpetual health instead.

Out on the river, anticipating rapids, the energy is high. Tom narrates canyon geology and throws in a few tall tales just to see if we're listening. Under the day's mounting heat I listen with my entire body but my ears pick up only the familiar words. Grateful that I will not be quizzed, my mind merges history and lore. I roll the words around on my tongue and come up with my own version of what I'm seeing—Bright Angel Shale, Vishnu Schist, and Angel Rock become the hymns I sing as we float down the river in our motorized gondola, flanked by majestic cathedral walls.

The closer we come to the churning water, the more the youngsters bounce, scream, and vie for the best positions. The rest of us grow giddy. I search Tom's face for a sign, to help me gauge the seriousness of our predicament. It's not lost on me that our guides have not once let slip a promise that we would survive it all. Kim didn't say it when, on my first hike, I found myself precariously perched on a narrow path surrounded by sheer cliff drops. She didn't even say it when I collapsed to my knees petrified and crying. What she did say was, "Hold my hand and keep your eyes on your feet. You can do it." I wanted to say, "Do you promise?" But I knew that it wasn't part of the deal. There is nothing in the canyon or this life, it seems, that can be reached or fully experienced

You always hear of the impact the Canyon has on a person—the ability it has to put things into perspective and to humble you. When I'm out there, all the petty things that take up my time in the "real world" seem so insignificant. This has had a very good influence on me. My life has been filled with some tragedies, not the least being that I lost my first husband in a scuba-diving accident when I was twenty-four. Coming to the Canyon and immersing myself in its beauty have brought a self-confidence and appreciation I never knew I was capable of, liberating me from the "baggage" of life.

DENISE TRAVER
Field Instructor, Grand Canyon Field Institute

without hanging your butt out over something a little terrifying.

By the third day I've taken up the lead position on the raft. I want to look inside the thing that scares me. I strap a small tape player to my body to record our voices as we go through the rapids. I will listen to it later, to decipher a mystery, and it will sound like passion—or sex—captured on tape.

We hit the rapids. The water drops and the boat plunges. Navigating huge rocks, we bounce inexplicably from crest to crest. The waves arc, we go under. Icy water walls hit, break, and pound us—my internal organs are rearranged. Hysterical laughter seizes me with such intensity that it makes everyone laugh. Whether a gift or a curse, I am keenly aware of the role chance plays, which makes me doubly thankful when we pop out the other side.

By the sixth day I've hiked over hill and cliff. I've taken on the waves and gone under the water. I've accepted help and forgiven myself human weakness. I've survived beauty and peril to see the world in canyon light, only to learn how many small but important things in my life I've left—out of fear—undone. I am mindful of my mother's voice in canyon wind, whispering safekeeping. To make peace with fear, I turn it inside out. It's the best I can do. It's more than I believed possible.

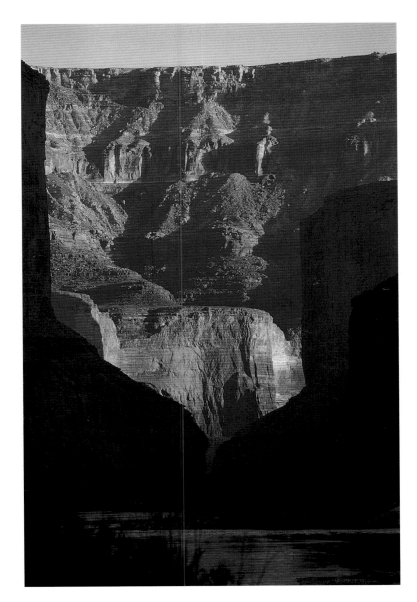

Marble Canyon

Travertine Grotto

S U S A N Z W I N G E R

Diamond Creek: Ugly boxes in lousy metallic colors on squat, black feet. Vehicular obscenities. Internal combustion intrusions. The first cars we've seen. Vans, actually, regurgitating enormous rafts and equipment. The boatmen are lashing together rigs big enough to carry **Manhattan.**

For the first time on the journey, we feel urgency. We must make it downriver to Travertine Falls before the crowds. Seven miles farther there is much cliff debris in the river, so the rafts must swing in first just above a rapid. Next come the dories.

This is the last full day of the nineteen-day trip, and my first day riding with Martin Litton, the Grand Old Man of the River. He has been saving the river since before I was born. Without him, the Grand Canyon would be just another slimy, trashed lake bottom above the proposed Marble Canyon dam site. How close we came to losing one of the most magnificent spots on Earth.

We tie up to Jeff's raft, and Lew Steiger helps Martin balance across the yellow tubes. The river roars directly underneath us toward the whitewater. I straddle the tubes with no grace, but the thought of body surfing these rapids holds no appeal. We scramble amid shed-sized hunks of limestone and schist tossed as if by an earthquake. Head down, I am admiring clear pools in pearly travertine basins formed when calcium carbonate precipitated out of limestone. Someone inevitably says, "Oh, schist!"

My head shoots up. Towering above us is orogeny with a sense of humor. Travertine Falls shoots out of solid rock hundreds of feet above us. I gaze in awe at the highly burnished Vishnu schist: black, metallic, scalloped bulges hump up the narrow chasm. A land of immense and regular flash floods.

I find a safer passage up near the canyon wall where the water has not scoured all the handholds out. Then standing below a seventeen-foot slick, vertical wall, I wait for my turn to use the stout rope a boatman has thrown down. I have good arm strength, but this leaning back into midair will take a leap of faith. To distract myself as I stand in line, I admire the whorls in the black stone which contrast the white travertine basins. Michael flies up the wall on his spindle legs, then the rope is in my hands. I lean back and find I can "walk" up ten feet, then traverse a ledge which lands me at the second-level pool and waterfall. There is no rope to help me up to the third level, and after several moments of confusion, I discover the travertine is as gritty as a carbon grinding pad. Bracing with my sandals, I'm able to hoist myself up.

The next level lies only twelve feet up and into a slit in solid rock where the water pounds. The side wall next to the pouring water looks impassable to me, although Bonnie, Lili, and John are scrambling up it with ease. I pluck myself from the line of human ants and stand under the waterfall while hoping to become invisible.

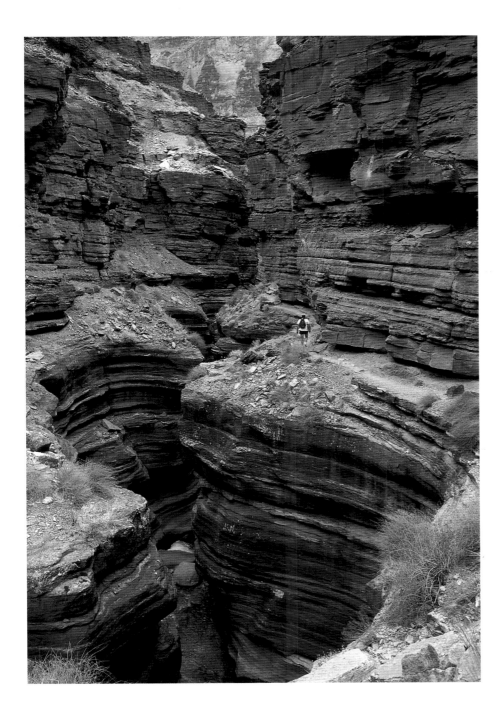

Hiking above Deer Creek narrows

I love this place. Although I don't consider myself an inhabitant of the Grand Canyon, I consider this my home. I do not live here simply because it is the Grand Canyon but because I have so much to learn: about this place, and about myself.

I work and play at the Grand Canyon. I breathe the air above and within the Canyon. I walk along the rim daily to be reminded of my commitment to preserving the integrity of the Grand Canyon wilderness. Within the Canyon, I can't help but be immersed, adapting to the extreme conditions. On the river or in the backcountry, I always find a new place within the Canyon universe, and am always amazed. The Canyon has given me unaccountable reward, professionally and personally. I wouldn't be who I am if it weren't for the Grand Canyon.

LINDA JALBERT
*Outdoor Recreation Planner,
Grand Canyon Science Center*

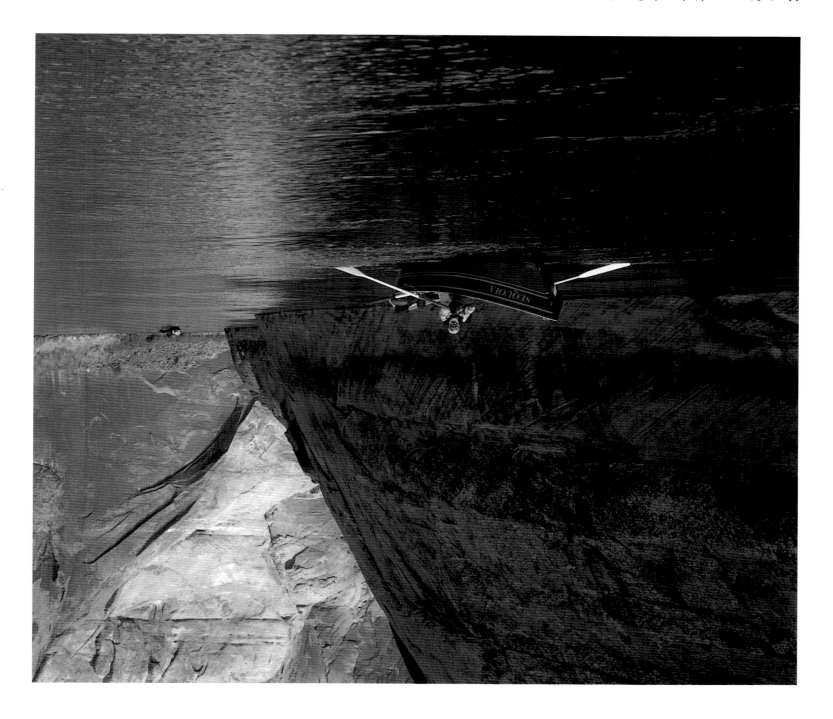

Underneath is a satin tapestry of pale green and chartreuse moss, yellow algae, and gleaming white travertine. Over it all shimmer the electric threads of whitewater.

"Susan! The handholds are easy," snaps Shawn. Since I rode in his boat, listened to his stories, and sang with him last night, I am definitely not invisible to him. I watch as he glides up the twelve feet of black stone, finding substantial knobs, keels, and ridges with his hands. The slick stone seems to wrinkle into ledges under his feet.

I sail upward, finding it embarrassingly simple and infinitely pleasurable. I do not have even a moment to savor this climb, however. We shuffle down a dark corridor whose sides themselves are filled with grottos. After the heat of midday, the cool dampness massages our skin. Fifty feet back the slit opens up into a palatial womb where a forty-foot waterfall smashes down over a stone lip. An even taller waterfall roars out of the heavens above that. The walls rise higher still to create a mysterious cylindrical room. Within it is an inner column of light where mist swirls in a microclimatic spiral.

Around the column stands a semicircle of drenched human beings—no, not merely drenched, but pouring off water, clothes flattened, hair parted to the point of baldness. Their grins are conspiratorial, I say to myself. Trouble.

"Get in the center," commands Bonnie. I crouch into the pounding waterfall like a timid animal, then back out. Suddenly it dawns on me that, even with all this water power, there is no pain. I fling myself back inside with arms stretched wide open and head tilted back, right up into the central air hole. A thousand pulsating showerheads pound, thunder, hammer, thrum, and pulverize my head. My clothes are pummeled, my hair is pummeled. All the dirt, sweat, bug juice, sun grease, nose snot, heat rot, and smoke scum are hosed off my joyful skin; my soul is polished clean.

The downclimb goes smoothly now that I have discovered travertine is as rough as a rasp. At the second-level waterfall basin, I pause, waiting for the rope. Martin is downclimbing slowly, painfully, over against the cliff. Since none of us can move past him, all eyes are glued to him, all our joints ache with each of his stiff joints, all our hearts are thumping with his. We are well aware of what a fall would mean to his fragile, eighty-year-old bones.

Yet there is not one of us who would deny him this challenge. We are all honored to have our tribal elder climbing with us, sharp as a tack, witty, loving life.

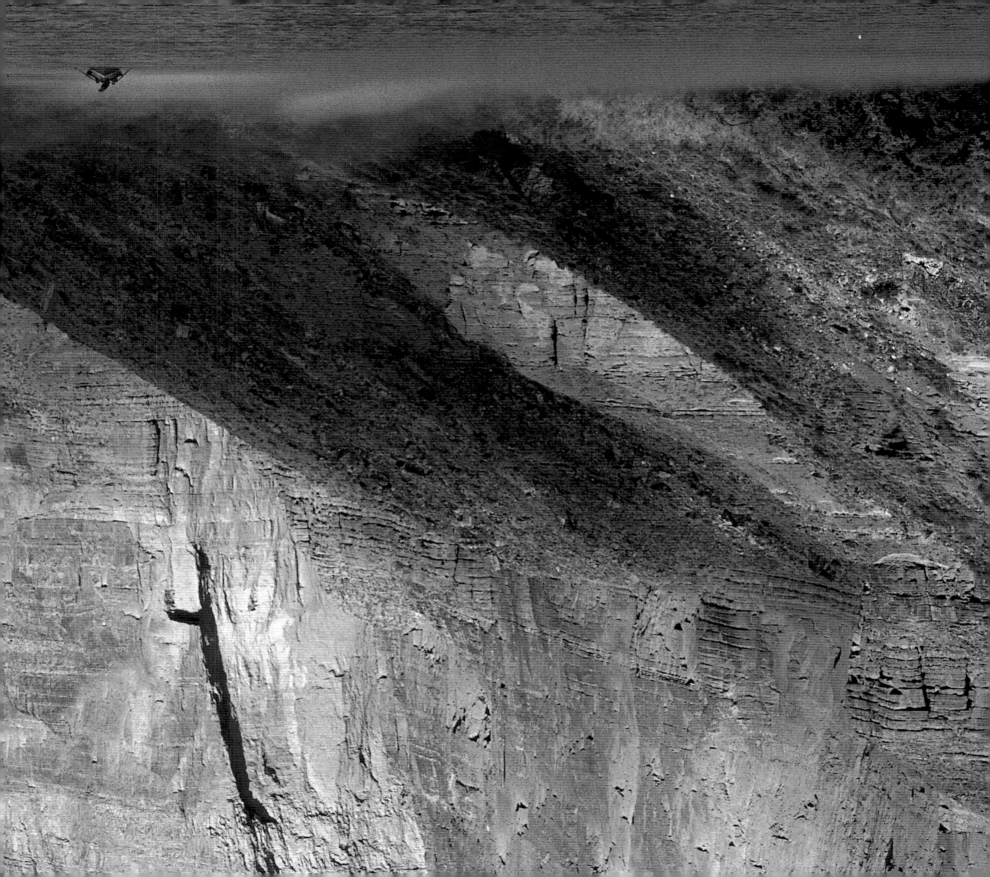

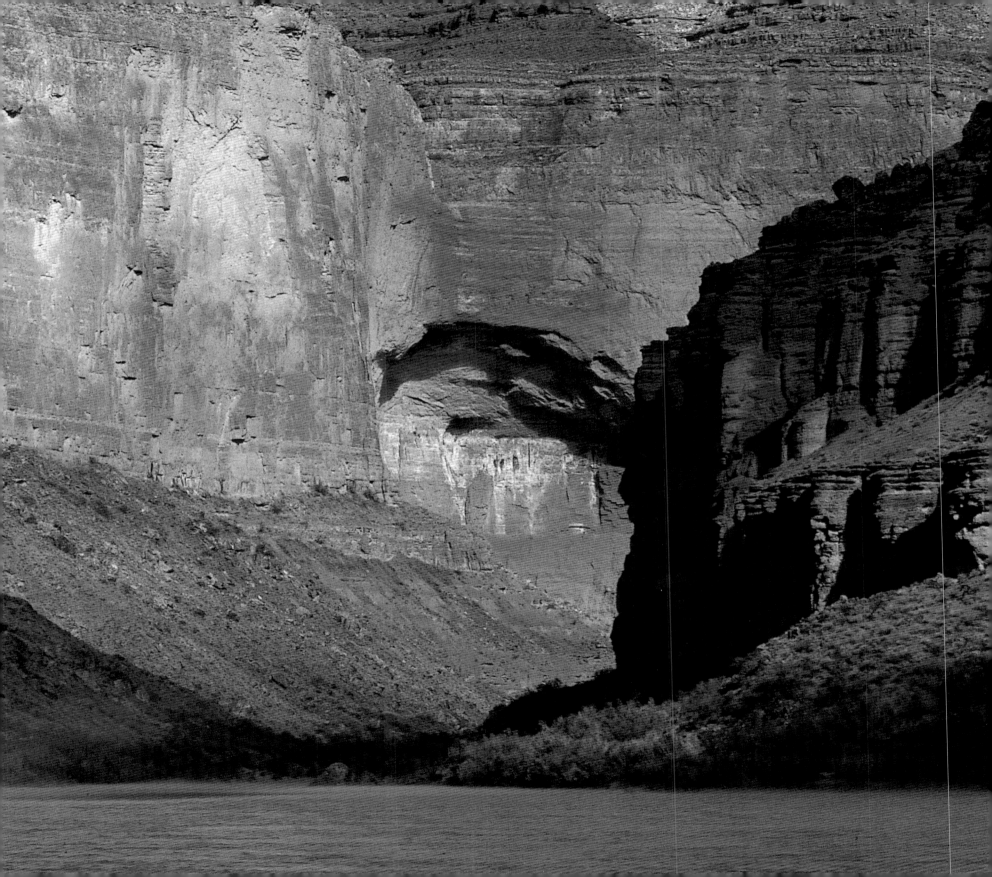

When I am finally handed the rope, I traverse and downclimb ahead of everyone else so that I may pee in peace. Crouching in the roaring mouth of Travertine Creek, I find pleasure in watching my body's chemicals mix into the Colorado. When I turn, three boatmen from the large tour company upriver have arrived and are staring at me.

"Hah!" I think. "This is how a *real* river woman lives. I bet none of your passengers loosen their decorum for their entire motorized, wimp-assed, two-day trip—even if they have to hold it in." What hubris I've gained from a little bit of rock climbing and nineteen days of freedom.

We clamber back into the boats and shoot out into the rapids. Lew, Martin's watch-person, takes another passenger, Don, into the *Sequoia's* bow and leaves me solo in the stern. He is coaching Don on how to trim, or balance, the lightweight dory so that it makes rowing easier for the eighty-year-old man.

Sadly, these are the very last of our rapids before the mighty Colorado is drowned, defrothed, and degraded into Lake Mead, and eventually into one wide mud slime down a Sonoran delta into the Sea of Cortez. Only a few rapids remain: Mile 231, Mile 232, Mile 234, and Bridge Canyon Rapids. Silenced is Gneiss Canyon Rapid and all the rapids below; Lake Mead has risen fifteen feet in this year alone.

With joy and mourning we enter these last rapids with Martin Litton. Martin sways us through the huge waves with the ease of an ice skater who, in midair, knows exactly how to land.

Pure, liquid beauty: an old man in a sea-blue hat, a bright yellow life vest, red oar handles twirling under reddened, gnarled hands, a bright turquoise dory, and white paddle blades dipping and gleaming. I attempt to re-experience the fear I felt a lifetime ago before the first rapids of this journey but cannot. I attempt to remember the cold, sodden misery of the first four April days of snow, sleet, and downpour but cannot. Instead, I balance high on the stern deck in sheer bliss.

Previous page: *Upriver of Saddle Canyon* Above: *Stacked rocks at Bass Camp hike*

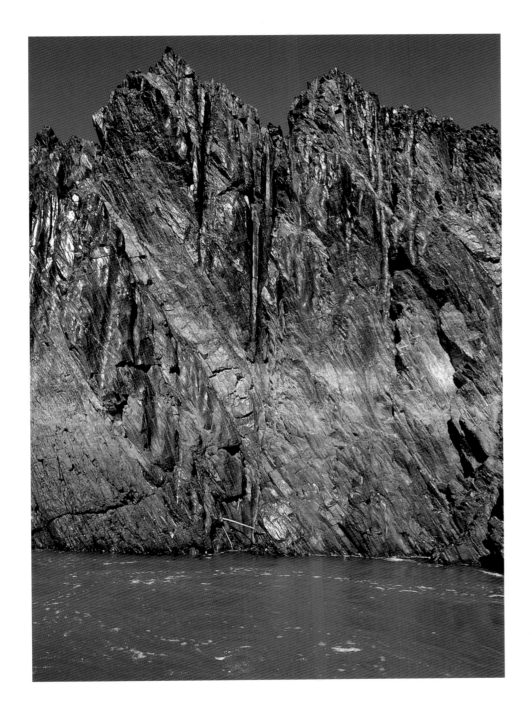

Schist

Martin spins us around completely and the *Sequoia* sweeps toward the muscular granite wall. I clutch the gunnels hard, praying, "Oh, no, not on your last rapids, Martin!" As we pass within a few feet of the canyon wall and out of the rapid, Martin is saying, "You wouldn't believe it from today, but last year I flipped right here in this rapid. Was so confident all the hatches were open. We lost all our stuff, but floated on down the river. . . . I popped up next to the boat. It is very different at lower water levels. I once sat in a chair with Lana Turner." And he launches into a story about the movie stars he met while fighting to save the Grand Canyon.

Now I understand why caretaker Lew Steiger was upright at the beginning of these rapids. These were the last of the substantial rapids. He stands and bows toward Martin with a huge shit-kickin' grin slicing his face. The Old Man has rowed almost the whole damned River at eighty. The all-time, Earth-wide, universal record. He has rowed it almost flawlessly with the precision timing of Itzhak Perlman, Bierstadt painting the waves. Lew clusters his fingertips, kisses them, and flicks them toward the sun. "That was golden, Martin, absolutely golden."

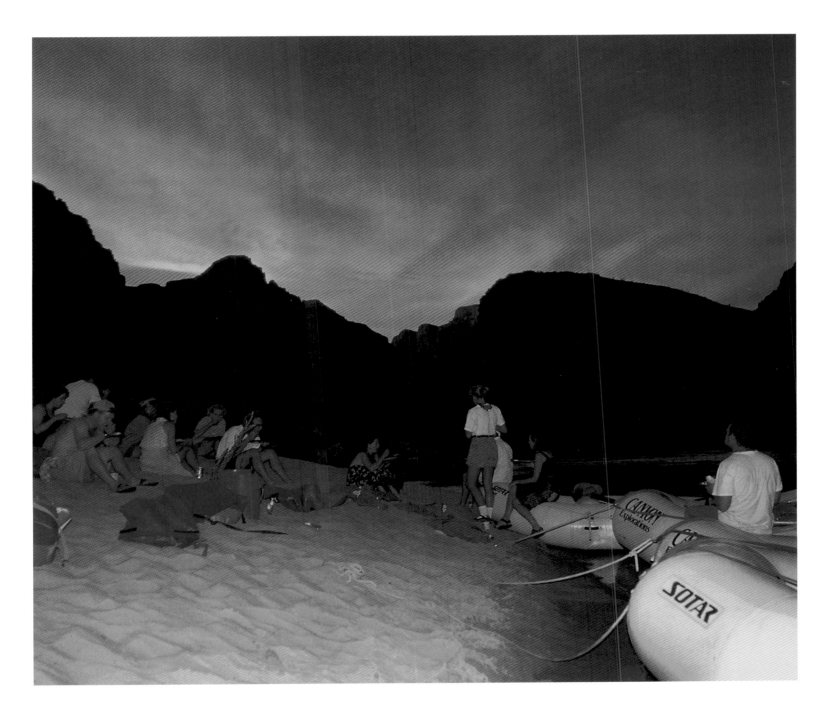

Sunset on last camp, Mile 221

Crossing Bitter Creek:
Meditations on the Colorado River

DENISE CHÁVEZ

I. HISTORY

There is a sense of the ludicrous in the scenario: A woman with a fear of heights and rapidly moving water, enclosed spaces, and small planes, a woman with bad knees (not a camper, who thinks that camping out is room service at the Holiday Inn), a desert woman who has no wool socks, no long johns, no rain suit, agrees to run the rapids on the Colorado River for a week then take a helicopter up to the rim to catch a small propeller plane to catch another plane to go back home.

My first and only trip to the canyon was in college, in the company of my mother, my sister Margo, Margo's French boyfriend Michel, and Michel's friend, a short dark-haired man everyone called Little Pierre to distinguish him from Big Pierre, a tall red-faced, blond-headed man. I was a drama major (and that explains a lot). My sister was an English major who hung out with foreign students. As for traveling in the company of your mother, well, that's another matter!

That trip was a blur: an all-day ride to Arizona with this mismatched group who sang folk songs on the way, while I stared out the window. My mother, on seeing the canyon for the first time in her life, was so overwhelmed she burst into tears.

But Mother was afraid of heights and squealed, "Stay away from the edge! Watch out, girls! Please! Please! Get away from there. You're going to make me cry."

We spent one night in a motel near the South Rim. The next morning Mother was ready to go home. There was nothing any of us could say.

I peered over the abyss and longed to discover the world below, knowing it was a dream for another time, another life.

II. THE NUN'S PERCH

More than twenty-five years later, in the dry and ghostly terrain of my unfamiliar adventure, I feel utterly alone. I meditate in my room at Marble Canyon Lodge during a terrific thunder and lightning storm, trying to catch news of Princess Diana's funeral, having come from a week-long silent Buddhist retreat with Thich Nhat Hanh, a Vietnamese monk. Only days ago, Sister Chân Không, his female counterpart, sang lullabies to us as we stretched face down on the hardwood floor of an enormous gymnasium in Santa Barbara, California, each of us offering our unspoken pain and immense sorrows to the earth.

I approach the river warily the first day, the only person completely outfitted in a rain suit. Everyone is wearing shorts and T-shirts and laughing and waving to the photographer on a nearby shore. I am somber underneath my cheap three dollar Hecho en México straw hat with the punched-in holes on the top. The brim is so large and stiff it bumps up against everyone and everything at every turn.

Tuckup Canyon

I am a frightened nun gripping the rope tightly, holding on for dear life. It's my mission to stay in this raft. I sit at the back of the boat, right-hand side, near the motor. I call it the "nun's perch."

My river adventure is so unlike anything I've ever done. I've only camped out once in my life, although I've slept outside on my deck at home many times. Water has always frightened me. I live in a flood zone and have suffered severe damage. When it rains, I become afraid. I recall a poet friend's advice on leaving town: "Don't drown."

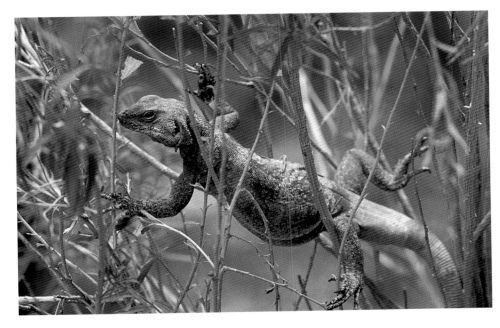

Our two rafts, one of fourteen people, the other of sixteen, put in at Lees Ferry. There is no turning back. I would never have come along if this wasn't an assignment. I don't know anyone, and they don't know me. The first-day perfunctory chatter is painful. I try to appear nonchalant, but I am terrified.

Silently I mouth my prayer to the river: "Mother, be gentle with me."

The first rapids are the worst of the entire trip. I stop breathing. I can't catch my breath, and when I do I immediately get water up my nose. It's the coldest water I have ever felt. I barely know how to begin to release my long-familiar fears, I am so used to being afraid.

When I am able to finally gather myself, I slowly breathe in and out. I remember Thich Nhat Hanh's words: "Breathing in I calm myself, breathing out I smile." I am also grateful to my cousin, Antonio Luján, whose sage advice comes back to me now: "Abandon yourself to the water. It's all about letting go."

Opposite: *Cottonwood at Nankoweap* Above: *Chuckwalla*

III. Crossing Bitter Creek

Throughout the trip I am struck by the similarities between this river road and the road I have just left behind. The name "Bitter Creek" is an all-too-real reminder of the terrible harsh road from Flagstaff to Page, Arizona, in the heart of the Navajo Reservation. The road is full of descansos, Spanish for resting place. These death markers pinpoint the spot where people have died by the side of the road. Any number of metal crosses line what should be fine open stretches of land.

The river, too, can be violent. I feel surrounded by spirits, some happy, some sad. There is torment here, and bloodshed. Sometimes I feel entombed in rock. Sometimes I feel as free as the ravens, those ancestral messengers who seek me out. To the others in our group, ravens are merely scavengers, here to pick up the scraps we leave behind.

IV. Descansos

The river's many ancestors call out to me to remember them: John D. Lee, ferry operator, executed by hanging for the Mountain Meadow Massacre. † Frank M. Brown, businessman, drowned surveying for a railroad that was never built, too cheap to buy life jackets. † Pete Hansbrough, drowned five days after Brown, survey crew member who inscribed notice of Brown's death in stone, mile 12. † Bert Loper, died of a heart attack while running 24½ Mile Rapid. † Mystery skeleton, found near South Canyon. † The 128 passengers killed in an airplane collision, June 30, 1956. † Norman Nevills, the first man to offer commercial river trips in the canyon, killed in an airplane accident with his wife, Mrs. Nevills. † The honeymoon couple, Bessie and Glen Hyde, whose bodies were never found. One legend says they drowned, another that Glen killed Bessie, yet another that Bessie killed Glen. Bessie was last seen being pulled against her will into a boat. † A horse hung after kicking out a cable cage built by William W. Bass. Mother, be gentle with them.

Motor raft in Granite Rapid

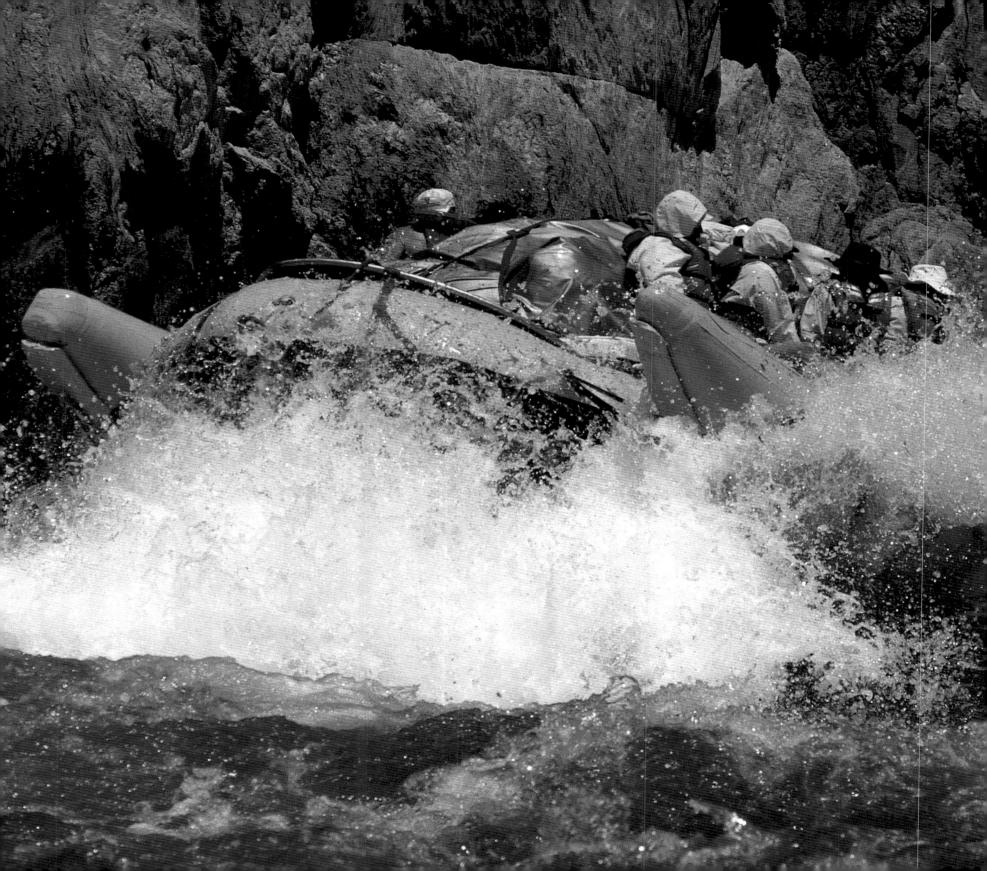

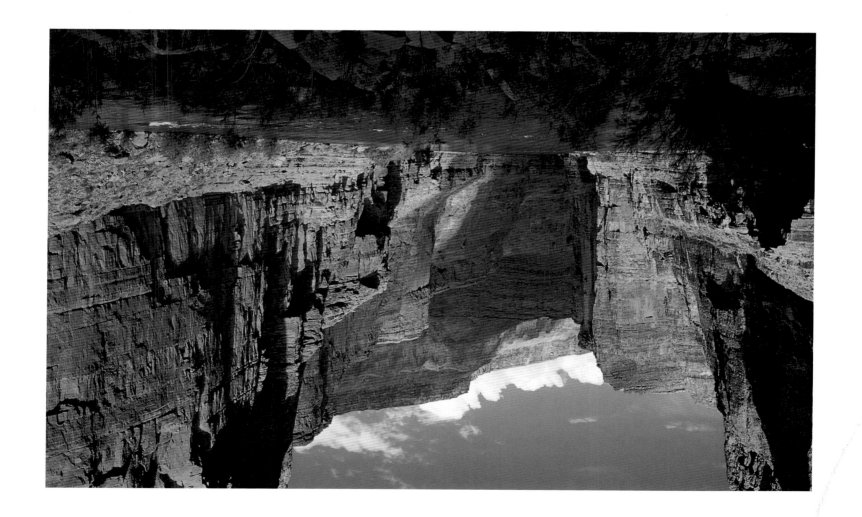

V. CRYSTAL RAPIDS

On our third day out, our guide Wade warns us to hang on tight. Today we encounter our first big rapids, a 10 on the scary scale. It can't be worse than the first day, can it?

I am consoled by sacred datura on the hiking path, the mother plant of dreamers. All will go well. Ravens are nearby.

Water, be gentle with us.

All day long a storm rages at our back. There is thunder, lightning, hard rain. "It's far away," Wade says, "it can't hurt us." I'm not so sure. My long johns with the negative ions and my wool socks keep me warm. Many of my companions are not so lucky. Later on we find that Crystal Rapids has had flash floods, and tossed a passenger overboard. There are whispers in our camp that night.

VI. MEDITATIONS ON FAMILY

Slowly I become more attuned to the river. She is unpredictable and strong, gentle and loving. The last days pass full of wonder, indescribable joy, broken now and again with sudden paralyzing anguish. I am overwhelmed by the smallness and fragility of our raft in this vast space.

One day I meditate on rocks. I have never seen so many rocks in my life.

One day I meditate on trees. It has never occurred to me that trees have families. There's a group of barrel cactus. Their will to live is so strong, they find their sustenance in the least likely places, in precipices and on a ledge of lava rock. There's a stand of tamarisk trees who greet me. They are never afraid. An irrational fear comes over me, a morbid dread. Something has spooked me and will follow me out of the canyon. Later I will have to have this spirit cleansed.

One day I celebrate my older sister Faride's birthday. She wanted to come along and how I wish she were here. My loneliness is a strong current. I sing "Happy Birthday" to her twice during the day when I find myself alone.

the ridge, or the muddy claret of the redwall limestone. Once, when I turned away from my own looking to take in my fellows, I realized that our boatman for the day, Scott, had set up his video equipment; Keith, a Missouri farmer, was taking notes for his book; Kathy, a Portland therapist, was photographing; and my husband, Hal, a radio producer, was recording the murmur of flat water and the roar of approaching rapids.

The children's author and artist Maurice Sendak once told an interviewer about his favorite piece of fan mail. A young boy had sent him a particularly charming drawing; Sendak sketched one of his wild things on a card and posted it back. A few weeks later, the boy's mother wrote that her son had loved the card so much he had eaten it. "That to me was one of the highest compliments I've ever received," Sendak told National Public Radio's Terry Gross. "He didn't care that it was an original drawing. He saw it, he loved it, he ate it."

Silver Grotto Camp

We were floating down Marble Canyon, a few miles below Lees Ferry, when the clouds closed in. Thunder reverberated off the steep walls—a sound not like any thunder I had heard before but a booming I might have expected in a siege of war. Lightning burst in blinding flashes and then the clouds let loose gusting torrents of rain. Suddenly the canyon itself seemed to blow apart as a hundred surging cataracts burst forth, great gushers of water that ran blood-red with dirt and rock and boulders twice the size of cannonballs. Even as the needled rain burned our skin, we huddled in a dust storm, the air thick with grit, excoriated from 1,200 feet of vertical fall, that scratched our eyes. When the rain let up enough we thought to look at one another, our eyes burned demon red.

Six guides accompanied us on our trip. Several of them had been down the canyon thirty times and more. Never, they all agreed, had any of them seen the canyon flash with such exquisite violence and beauty. Over the next twelve days I learned that each of them, on every trip, sees something he has never seen before.

My etymological dictionary tells me that the word "awe" comes from the Old Norse *agi*, akin to Old High German *agisōn*, to frighten; from the Gothic words *agis*, fear, and *ōg*, I am afraid; from Old Irish *agōr*, I fear; and, more remotely, the Greek *akhos*, distress or pain. Our contemporary sense of the word retains some vestige of these origins; *Webster's New World Dictionary* defines awe as a mixed feeling of reverence, fear, and wonder caused by something majestic or sublime. For twelve days and 280 miles on the river, I was filled with awe—so struck by it, that if I have any courage at all, I shall never be the same.

Overindulgence is a sin, but Aristotle thought it impossible to take in too much beauty. On the river, I found myself drunk with visual excitement, engaged in a gluttony of looking. Among the few possessions that I had stuffed into the grocery-bag-sized dry sack that carried my belongings, I packed a small box of watercolors, and I stole away from our group for a few moments each morning and afternoon to paint. Often I would try to recall something I had seen on the river. Other times I would focus on something directly in front of me: a family of barrel cacti in the late afternoon sun, a single cube of Zoroaster granite. On the rafts I found myself looking with an engagement that made me blind to everything else, often forming a peephole with the crook of my little finger, trying to isolate, to understand, the purity of that particular gold of morning light on

I am not the first person to fall in love with Grand Canyon, and I will not be the last. It is a place where one can be both humbled and empowered in the same instant, and it is the most dramatic theater for experiencing the opening of others' minds.

How does one explain that at a certain point, as she was walking through her life, she stepped into the first place that has held her soul like no other, that this place is like her temple, her home, her refuge, her love? She does not explain it; she shares it.

NICOLE J. CORBO
River Guide

Barrel cactus in bloom

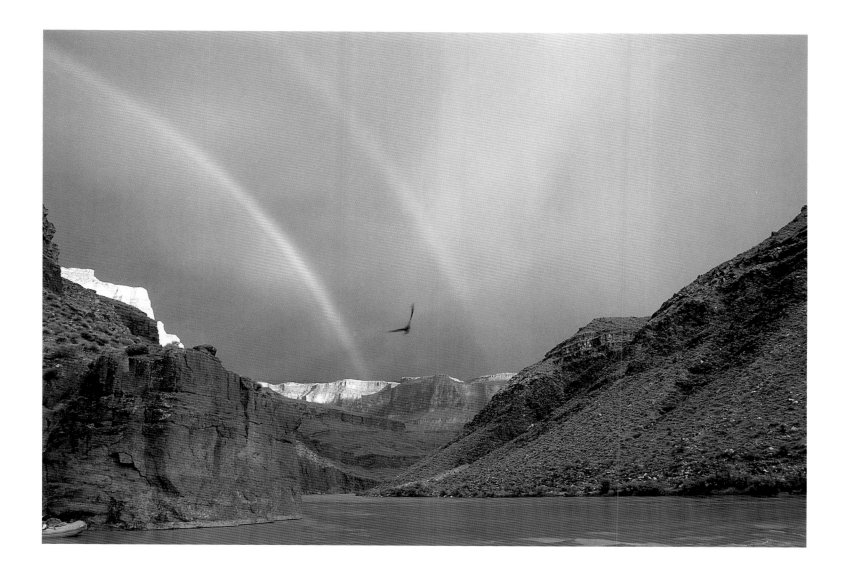

Double rainbow at mouth of Tapeats Creek

Sustenance

TERESA JORDAN

During the afternoon of our first day on the river,
the world exploded.

Andy Hutchinson rowing the dory Temple Butte in Hermit Rapid

What feeds us, and what do we merely consume, insatiably hungry for more? As we floated off early one morning, I gazed upriver at receding lines of cliffs and talus slopes as they met the banks in the interlace of fingers in prayer. That evening, as I tried to recall the spectrum of blues, from the almost translucent cerulean of the slopes closest to me to the misty indigo of those farthest away, I yearned, with my tiny sketch, to ingest the blood and body of river and rock, not only to take it in, but to enter into it, to transcend, if only for a moment, the tissue that divides us from that which is not us, the mundane as much as the mystical and sublime.

I had climbed the steep hillside above our camp to paint, and when I finished I hiked down to join the easy conversation around hors d'oeuvres that had become the nightly habit of our group. That night, we talked about Princess Diana; her death had been the last news to reach us before we put in. The event had accompanied us these days on the river, a partner to the extraordinary power and beauty that swept us downstream, and now we wondered about the insatiable fascination that had hounded her literally to death, and our own part in it. Many of us were grateful for the distance the Canyon gave us from the media orgy that we knew had erupted around the tragedy, and the titillated addiction we would have given into if we had access to the news. What did we—the world at large, and our own small selves—need from her? What hunger did we think she could satisfy? How full must we be before we cease to grab what glitters, just because it's there?

I asked myself this last question again a few mornings later when a small king snake crawled along a half-inch crag in the limestone behind our camp. We gathered to watch him and he grew perfectly still, aware of us but not, apparently, much disturbed. He was a beautiful thing, only two feet long, striped black and white with the precision of fine painted porcelain. I made a move for my camera and startled him. He jerked perceptively and then slithered away. I still wonder what I thought a photograph might have captured that a longer moment of stillness would have failed to reveal.

Late in the afternoon of the eleventh day, shortly before we made camp for the last time, we stopped at Travertine Falls. We climbed a narrow slot in the limestone and shimmied up a sheer wall of gleaming black schist to reach a small travertine cathedral under a forty-foot waterfall, lit by a single shaft of sun. Each day on the river, embraced by such wonders, I had thought, *This is the most magnificent sight I have ever seen. Surely,*

nothing can exceed this. A few miles later, the canyon would prove me wrong.

Our final morning, as I sat on my sleeping mat to sketch, I thought I would try to capture some essence of Travertine Falls. Instead, I found myself painting our black rubber dry bags: dark, amorphous shapes that nonetheless held, in the clarity of attention, a beauty as surprising as sunlight on schist. The bags were right in front of me; such mundane objects had been in front of me every day of my life. In awe, I realized I had never seen them, *really* seen them, before.

A river trip is a journey. If the current is strong, you don't go back, only farther along. On noon of the twelfth day, we reached Pierce Ferry, the end of our trip. We gathered with our river friends for one last meal—turkey sandwiches laid with dark green leaves of romaine and glistening jewels of cranberry sauce—and talked about how to hold onto the many gifts of the Canyon. We talked, too, about the news that had greeted our landing, the death of Mother Teresa. After lunch, Hal and I packed our car to drive twelve hours straight home; Hal needed to catch a plane to New York in the morning.

Late that night, as the long yellow beams of our headlights cut across the black Nevada desert, I fell asleep and dreamt of gauzy white cotton backlit by sun, billowing under a deep azure sky. Just as I realized I was dreaming of India, I woke to hear Mother Teresa's funeral on the radio. The reception was poor and full of static; it drifted in and out and came from very far away, a dream itself perhaps, or a sacred invocation. I reached out to my husband. "Are you okay?" I asked. "Do you want me to drive?" "I'm fine," he answered. "I'm good." He squeezed my hand, then put his own back on the wheel. We drove on through the night toward the comforts of home, looking for the courage to change our lives.

Dry bags

Acknowledgments

My life is bountiful with exceptional people, and I am very grateful for their continued friendship and love. We are mutually guided by a Divine Source, which feeds my soul, fills my heart, and provides strength and inspiration to venture into the unknown. This is my opportunity to thank them:

To my gracious friends and abundant extended family: Bonnie MacLean Abney, Pam Frazier, Nancy Wolff, Ami Garthwaite, Elna Iverson, Janice Vaughn, Sue Brown, Joy Turner, Cheri Bottero, Vivian McAteer, Brea McGrew, Carla Curry-Lovelady, Jewel Van Valin, Pat Halverson, Helen Nelson, Linda Warder, Trina Smith, Molly Callahan, Sophie Echeverria, Ellyn Cliften, Terry Zweesloot, Kitty Collins, Jan Lea, Norm Dress, John Michael Ryan, and Aunt Connie MacLean. A special thank you to Pauli Van Valin, Ann Harris, Georgeanne Oswill, Bobbie Russell, Bev Rhode, Stuart and Helen Anderson, Frances Gardner, and Tom Claget, Jr., for their generous support.

To each of the writers for their trust in me, the project, and themselves, and sharing their profound personal expressions of the Canyon experience.

To Northland Publishing: Erin Murphy, editor-in-chief, and Karen Anderson, marketing director, for their gracious and enthusiastic working partnership; Jennifer "Brilliant" Schaber, art director, for her spectacular design and production of this book; Aimee Jackson, Billie Jo Bishop, Lisa Brownfield, and Angie Zbornik for all their professional support.

To Peter Ryan for introducing me to the River. To Sallie Sargent and Amy Root at America West for their gracious and efficient handling of all air transportation. To the Grand Canyon outfitters: John Vail, Laurie Lee Staveley, Bruce Winter, Bill Gloeckler, Mike Denoyer, Rob Elliott, George Wendt, Mark Slight, Clair and Pam Quist, and Richard Quist for providing exceptional river trips for everyone. To Howard and Sally Krueger, Clay Porter, Bob Button, Jane Foster, Don Foster, Doug and Pat Walker, and Leslie Carpenter for their wonderful accommodations. To Mike Taggett, Christina Urso, Ann Wren, Chris Thurston, Steve Verkamp, John Verkamp, Mel Potter, Dr. Scott and Dr. Ann Bradley, Dr. Clara Lovett, Jeanette Baker, George Handley, Leia James, Leslie Thatcher, Chris Hinkle, LaVelle McCoy, Chuck Upton, Brenda Halvorson, Tom Myers, Lou Grubb, Barb and Mark Dinunzio, Elaine and Larry Gourlie, and Bob Koons, for their financial and product support of this book, and to Dave and Mimi Demaree, D.I.B.; Lisa Pratt, Pelican Products; Courtney Mathews, Sierra Designs; and Colleen Brady, Sundog, Inc., for additional equipment.

To the boatmen and other members of the river community for their patience and guidance: Jeri Ledbetter, Julie Munger, Tom Vail, Kent Morby, John O'Brien, Deb Dohm, Steve Lonie, Garrett Schniewind, Mike Denoyer, Andy Hutchinson, O'Conner Dale, Chuck Wales, Allen Gilberg, Derald Stewart, Bert Jones, Bob Young, Dave Edwards, and Lew Steiger.

About the Contributors

Kathleen Jo Ryan

DENISE CHÁVEZ, novelist, short story writer, playwright, actress, and teacher, is a native of Las Cruces, New Mexico, where she teaches creative writing at the New Mexico State University. Chávez has been honored for her philanthropic work, as well as her writing, with awards such as the New Mexico Community Foundation's Luminaria Award, the Soroptimist International of the Americas Club's Woman of Distinction Award in Education, the New Mexico Governor's Award in Literature, and *El Paso Herald Post*'s Writers of the Pass award. Chávez is the author of *Face of an Angel*, which won the Premio Aztlán award and the 1995 American Book Award. She is also the author of *The Last of the Menu Girls* and several plays, including *The Woman Who Knew the Language of the Animals*. A deeply committed community-based artist, Chávez continues to explore the universal in the regional landscape. She is currently working on a novel, *Loving Pedro Infante*.

GRETEL EHRLICH was born in Santa Barbara, California, and educated at Bennington College and UCLA Film School. She moved to Wyoming in 1976, where she lived and worked on sheep and cattle ranches for seventeen years. Her published work includes poetry, fiction, nonfiction, essays, and memoir, including *Geode; Rock Body; To Touch the Water; The Solace of Open Spaces; Drinking Dry Clouds; Heart Mountain; Islands, the Universe, Home; Arctic Heart; A Match to the Heart; Yellowstone: Land of Fire and Ice;* and *Questions of Heaven*. Her work has appeared in *Harper's, The Atlantic, The New York Times, Time, Life, Architectural Digest, Antaeus,* and *Outside*, among many others. She has been honored for her writing by the National Endowment for the Arts, the Whiting Foundation, the Guggenheim Foundation, and the American Academy of Arts and Letters. Ehrlich now divides her time between the central coast of California and Wyoming.

LINDA ELLERBEE has earned a reputation over twenty-five years as a highly respected and outspoken journalist. Her notability as a network news correspondent, anchor, writer, and producer has positioned her to head Lucky Duck Productions, a successful and award-winning television production company. Ellerbee's first book, *And So It Goes*, remained on *The New York Times* bestseller list for five months. Recognized as the most candid portrayal of television news ever written, it is used as a textbook in more than a hundred colleges and universities across the country. Ellerbee's second bestseller, *Move On*, presents a bold and honest portrayal of her own adventures in life.

TERESA JORDAN is the author of the memoir *Riding the White Horse Home* and of *Cowgirls: Women of the American West*. She has edited two anthologies of Western women's writing (*The Stories that Shape Us: Contemporary Women Write About the West* and *Graining the Mare: The Poetry of Ranch Women*). The recipient of an NEA Fellowship in literature and the Silver Pen Award from the Nevada Writer's Hall of Fame, she lives on a hay meadow in northern Nevada with her husband, folklorist Hal Cannon, and is currently at work on a novel, *Sleeping with the Animals*.

LINDA HOGAN is a Chickasaw poet, novelist, and essayist. Her novel, *Mean Spirit*, was one of three finalists for the Pulitzer Prize in 1991. Her collection of poems, *The Book of Medicines*, was a finalist for the National Book Critics Circle Award. Her two most recent books are *Solar Storms* and *Dwellings: A Spiritual History of the Natural World*. Hogan has received an NEA grant, a Guggenheim fellowship, a Lannan Foundation Fellowship, and The Five Civilized Tribes Museum Playwriting Award. She is a professor at the University of Colorado and has taught writing workshops at universities and in Indian and rural communities.

JUDITH FREEMAN is the author of a collection of stories, *Family Attractions*, and three novels—*The Chinchilla Farm, A Desert of Pure Feeling*, and *Set for Life*, which won the Western Heritage Award for Best Novel in 1991. Her reviews and essays have appeared in many publications, including *Life*, *The New York Times, The Los Angeles Times*, and the *Washington Post*. A recipient of the John Simon Guggenheim Fellowship in Fiction in 1997, she divides her time between residences in Los Angeles and Idaho.

Anthony Hernandez

Karri Kelly

Alan Bell

RUTH KIRK lives in Lacey, Washington, where she continues the writing and photography begun with her husband (recently deceased), who was a park ranger for 23 years, then a TV documentary producer. She has written nearly three dozen books dealing with natural history and culture, including *Death Valley* (with Ansel Adams and Nancy Newhall), *The Olympic Rain Forest: An Ecological Web* (with Jerry Franklin), and *Japan: Crossroads of East and West.* Kirk's nearly two dozen awards include the John Burroughs medal and nomination for the National Book Award.

PAGE LAMBERT has won numerous honors for her writing. *In Search of Kinship*, her first nonfiction book, was picked by the *Rocky Mountain News* as "one of this summer's hottest reads." Her first novel, *Shifting Stars*, was published in 1997 to critical acclaim. Her work is aired on National Public Radio and is part of the Wyoming Nature Conservancy's "Range of Respect" radio presentation. A Colorado native, she is a founding member of Women Writing the West, a member of Bearlodge Writers, Wyoming Writers, and an active member of Western Writers of America. Lambert currently lives on a small ranch west of Sundance, Wyoming, with her husband Mark and two teenage children.

BRENDA PETERSON is the author of three novels, including *Duck and Cover*, which was a *New York Times* Notable Book of the Year for 1990. Her nature writing collections include *Nature and Other Mothers* and *Living by Water*, which was an Editor's Choice for the American Library Association. She is an environmental writer for such publications as the *Seattle Times, Sierra, Orion*, and *New Age Journal*. Her other work has appeared in *The New York Times, Utne Reader, Modern Maturity*, and *Reader's Digest*. Peterson is an NPR commentator and is featured in *Edge Walking on the Western Rim: New Works by 12 Northwest Writers* and in the 1994, 1995, and 1996 volumes of *American Nature Writers*. Her most recent nonfiction book is *Sister Stories: Taking the Journey Together*, and she is co-editor with Deena Metzger and Linda Hogan of the new international anthology *Intimate Nature: The Bond Between Women and Animals*.

Dan Foster

ANNICK SMITH, a writer and filmmaker born in Paris, France, and raised in Chicago, has lived in western Montana since 1964. She is a widow and has raised four sons on a homestead ranch in the Blackfoot River valley. *Homestead,* published in 1996, is a collection of her essays. Smith was co-editor with William Kittredge of the Montana anthology *The Last Best Place.* Her latest book, *Big Bluestem: Journey into the Tallgrass,* is an illustrated volume about the natural life and human history of the Osage tallgrass prairies of Oklahoma. She compiled and edited *Headwaters,* an anthology about waters and wilderness by Montana writers, which was distributed free during 1997 to promote conservation.

SHARMAN APT RUSSELL is an assistant professor in general studies at Western New Mexico University in Silver City, New Mexico, where she lives with her husband and two children. She has received numerous awards for her books and essays and recently completed her novel about Clovis times in the Mimbres Valley. Russell, the author of *Songs for the Flute Player, When the Land Was Young,* and *Kill the Cowboy,* is now composing a collection of essays about Quaker values, entitled *Standing in the Light.*

LEILA PHILIP is the author of *The Road Through Miyama,* which received the 1990 PEN Martha Albrand Citation for Nonfiction. Her second book, *Hidden Dialogue: A Discussion Between Women in Japan and the United States,* was published in 1993. She was honored by the National Endowment for the Arts and has been the James Thurber Writer in Residence in Columbus, Ohio, and a Bunting Fellow in Creative Writing at Radcliffe. She currently teaches creative writing in the English department at Colgate University and is at work on a new book of nonfiction. She and her husband and son divide their time between Hamilton, New York, and New York City.

BARBARA EARL THOMAS, a noted painter, was born and raised in Seattle. She has had artwork in exhibits and collections throughout the U.S. and is represented in Seattle by the Francine Seders Gallery. Her essays have appeared in numerous publications and anthologies, including *Raven Chronicles*, *Aorta*, *Gathering Ground*, *A Single Mother's Companion*, *Calyx*, and *Intimate Nature: The Bonds Between Women and Animals*. *Storm Watch*, a book of her painting and writing, is forthcoming from the University of Washington Press. Since 1989, she has worked as advertising manager at the Elliot Bay Book Company.

EVELYN C. WHITE is the author of *Chain Chain Change: For Black Women in Abusive Relationships* and editor of *The Black Women's Health Book: Speaking for Ourselves*, a landmark collection that has received numerous awards. A nationally recognized lecturer on feminist issues, White is a director of the Soapstone Women's Writing Retreat and the Harvard Club. Currently she is a visiting scholar in women's studies at Mills College in Oakland, California, and the official biographer of Alice Walker.

ANN HAYMOND ZWINGER is a prolific and highly respected American nature writer. Over the last three decades she has published many books, including *Downcanyon: A Naturalist Explores the Colorado River through the Grand Canyon*, *Writing the Western Landscape: Mary Austin and John Muir*, *A Conscious Stillness* (with Edwin Way Teale), and *Run, River Run*, as well as dozens of essays in major publications. Zwinger has shared her craft at numerous colleges, universities, and organizations and is the recipient of the prestigious John Burroughs Medal for *Run, River, Run*.

About the Photographer/Producer

Herman Zwinger

KATHLEEN JO RYAN is an accomplished photographer and producer of books and videos, including *Irish Traditions* and *Ranching Traditions: The Living Legacy of the American West* and its companion video, *Ranching*, with Charlie Daniels.

Ryan, who now lives on an island northwest of Seattle, Washington, grew up raising livestock in the foothills of northern California. Her love of the land and people has inspired her to travel over 300,000 road miles throughout twelve western states and Ireland, photographing ranch life, river life, and the people of Ireland. In addition to being included in her books, her photographs have been exhibited by the Pro Rodeo Hall of Fame and Museum of the American Cowboy, the American Quarter Horse Museum, the Rochester Museum and Science Center, the Russell Senate Building Rotunda, the Coconino Center for the Arts, and various galleries.

Ryan's creative vision is imbued with heartfelt affection for her subjects. She finds a niche and tells a story in the most authentic, poignant, entertaining way. She is committed to showing that substance and truth are more powerful than myth, while each book reflects her passion, philosophy, and artistry.

SUSAN ZWINGER lives on an island off the coast of Washington, where she has just completed her fourth book, *The Last Wild Edge: One Woman's Journey in Search of Ancient Forest*. Her first book, *Stalking the Ice Dragon: A Naturalist's Journey through Alaska*, received The Governor's Writers Award in 1992, as well as enthusiastic reviews in diverse journals. Zwinger has combined her interest in the natural world, her skills in teaching, and her talent as both a writer and an artist in her varied professional work and as a dedicated volunteer.